Gregory Martin

HIERONYMUS BOSCH

With 41 color plates

ST. MARTIN'S PRESS NEW YORK

Published in the United States of America in 1979
by St. Martin's Press, Incorporated,
175 Fifth Avenue, New York, N.Y. 10010

© Blacker Calmann Cooper Ltd, 1978
This book was designed and produced by
Blacker Calmann Cooper Ltd, London

Library of Congress Cataloging in Publication Data
Main entry under title:
Hieronymus Bosch.
 1. Bosch, Hieronymus van Aken, Known as,
d. 1516 – Catalogs. I. Martin, Gregory.
ND653.B65A4 1979 759.9492 78–19811

ISBN 0–312–37214–0
Printed in Spain by Heraclio Fournier, S.A.

Introduction

COMPLEX BUT IMMEDIATELY DIRECT, at once conservative and revolutionary, the work of Hieronymus Bosch still holds many secrets and yet is universally admired. Little is known about this artist who spent his life in 's-Hertogenbosch in north Brabant and was buried there on 9 August 1516. He was remembered there as 'insignis pictor'. In his own lifetime, his art was admired outside the confines of his native city; later in Philip II of Spain he found an ardent admirer and his reputation lived on in the Netherlands for at least a century after his death.

Bosch was first a genius who looked afresh at man in his everyday life, translating into oil paint what earlier miniaturists in the Netherlands had depicted in, for instance, their Calendars of the months of the year. In this sense his roots may have been similar to those of Jan van Eyck, the chief founder of the tradition of oil painting in the Netherlands, who died in 1441. Bosch's vivid realism, his gift of observation of people and their emotions, his consummate ability to record the poor and the rich, the beggar and the bourgeois, the rough and the refined, ensures him an important place in the development of genre painting in the Netherlands. Indeed, as he was to exert a profound influence on Pieter Bruegel the Elder, Bosch's role in the later flowering of Dutch painting may be seen as crucial.

In the development of landscape painting, he played a significant part as well. On the outside of the shutters of his most famous triptych, *The Garden of Earthly Delights*, he painted the first (extant) pure landscape in the Netherlands. This was a view of the world on the third day of creation, an extraordinary theme, well beyond the boundaries of his contemporaries' visual vocabulary. His relationship with the art of Patenier, who was soon to make landscape a speciality in Antwerp, is not clear. But certainly the landscape settings that Bosch chose for many of his paintings and the distant panoramas — so clearly inspired by his native land — that he often included as background, reveal both the breadth and the originality of his vision. In his art, landscape assumes a new and significant emphasis.

But it is neither as landscapist nor commentator on everyday life and man's manners and attitudes that Bosch is renowned today. His fame rests on the visionary nature of his art and on his extraordinary imagination. His scenes of hell are apocalyptic pageants described with an unnerving sense of detail. In these doom pictures, Bosch summed up a long medieval tradition: connections and sources for his renderings of hell can be found in earlier art forms, both literary and pictorial; but no one before had brought such a wide-ranging fund of ideas to such a perfect pitch of detailed expression.

In a century when Surrealism has been discovered as a legitimate style and subject for artistic exploration, Bosch's most famous work, *The Garden of Earthly Delights*, has attracted an added interest that would have gratified its sixteenth-century admirers in Spain. The central compartment of the triptych shows a myriad of naked human beings in a state of dreamlike bliss surrounded, and often dwarfed, by birds and exotic animals; here and there are strange, finely shaped edifices. Only recently has the meaning of this enthralling work been found in astrology and alchemy. In it Bosch

made great art out of a mode of thought and an abstruse discipline which for long has remained ignored and neglected in the history of European culture.

A provincial, still 'medieval-minded', Bosch reveals the complex, fear-ridden hopes and anxieties of a local, orthodox intelligentsia, whose long-developed culture was soon to be put to the test by High Renaissance and Protestant forces of change. That culture with its belief in magic and demons, its ever-present fear of the Day of Judgement and of damnation, found its greatest expression in Bosch's art. But its irrelevance to the international, reforming movements of the time, which were soon to sweep it away, has made his art difficult to understand, however much it fascinates.

As in the case of so many artists of his era in the Netherlands, very little is known about his life. Some thirty archival records in 's-Hertogenbosch have been discovered that refer to Jheronimus (or in its Dutch form, variants of Jeroen) van Aken, the surname of the artist who in his middle or late career adopted the name Bosch. The significance of this gesture is obscure; certainly it was unusual to take on a new name that in part referred to his native city. Perhaps it denoted a self-awareness or recognition of his, not merely local, pre-eminence. Bosch came from a family of artists. His grandfather, who died in 1454, had been active in 's-Hertogenbosch: a *Crucifixion with the Virgin, St John and donors* in the cathedral of St John has been attributed to him. But it has also been suggested that Bosch's artistic forbears were miniaturists, in which case none of his grandfather's work is known, nor has any work survived by Bosch's father, Anthonis, or by any of his three uncles, who were also recorded as artists.

Handling the brush was certainly in Bosch's blood, and the atmosphere of the workshop or studio must have been among his very earliest experiences. If the fresco in St John's church is accepted as the work of Bosch's grandfather — if not, it at least indicates the type of work Bosch would have known in his youth — and if Bosch's presumed early works are taken as evidence, it is clear that the mainstream development of oil painting in Flanders never gained full acceptance, or was never considered relevant, in 's-Hertogenbosch. Bosch on his travels was to absorb one masterpiece by Jan van Eyck, but it is impossible to relate his art intimately to that of any of his famous predecessors, as his interests were fundamentally different.

His working method too may have differed, for he is the first painter in the Netherlands to whom a corpus of drawings can safely be ascribed, consisting of both *modelli* and working sketches, executed in a technique more reminiscent of the miniaturist than the contemporary painter. There are some twenty drawings in quill pen or brush extant today which are considered to be his work. If it is assumed that the execution of such studies formed part of his normal working procedure, many must have been lost. Of those that remain, some reveal Bosch as a fantasist, inspired by memories of Gothic monsters whether carved, introduced as borders to illuminated manuscripts or painted on church walls in frescoes which were soon to be obliterated by white-wash, as the tide of the Reformation reached full flood in the Netherlands. Other drawings show him to be the observer of everyday facts, of beggars and cripples in particular. Here Bosch is Bruegel's real precursor. However obscure his painted subject-matter appears to us now, we recognize its validity because Bosch was at heart an observer, both witty and acute, of life about him.

His extant painted *œuvre* consists of about thirty-five works; a fairly large number of other paintings in his style indicate either a larger produc-

tion or the existence of studio assistants or followers capable of imitating or varying their master's ideas. In 1503–4, in fact, a record was made of the payment for painting three coats of arms, and in it Bosch's apprentices were mentioned. Needless to say, scholars differ both on the status of some works often included in the corpus and on the extent to which Bosch was involved in the works painted under his influence.

Although his exact date of birth has not been discovered, the year 1475 is generally accepted as his point of departure as an independent artist. By 1481 he had married a patrician's daughter, which indicates that he was then considered able to make his way in his chosen artistic profession. There is no record of illness or declining powers, and thus it has been assumed that he was active over a period of forty years. Even taking into account known losses and putative losses (suggested by near-contemporary works in his style not considered to be by him) his painted *œuvre* can be estimated as not large. A slow, steady devotion to his calling is indicated, which is likely, given the detailed, intricately worked character of much of his extant work.

He occasionally signed but never dated paintings or drawings, and thus the development of his style is a matter for conjecture, as apart from costume, there is little external evidence available (such as commissions for extant works). He was by no means frightened of the large format, but his favourite scale for figures tended towards the small, pointing, perhaps, to a love and appreciation of miniatures. Thus his greatest works, even taking into account his skill at organizing crowds and his compositional aptitude, have an encyclopaedic quality that demands minute study. Some works using figures on a near life-size scale show his readiness to consider contemporary trends towards the High Renaissance style then being explored in Antwerp by his contemporary Quentin Massys. But these works by no means reveal the full power of his genius and imagination. His greatest works are those of a miniaturist writ large in oil paint, an unusual formula best attuned to express his original, learned and imaginative concept of Christianity and man's spiritual destiny.

Most of the documents that refer to Bosch's life are connected with an important local society, the Brotherhood of Our Lady. He was one of 353 members to be listed in the year 1486–7. Bosch was called upon to advise the Brotherhood on the embellishment of a carved altarpiece of Our Lady and later was paid for having provided for it a model of the Cross. His active membership of this lay confraternity testifies both to Bosch's orthodoxy and his religious fervour; it shows too that he was a respected member of the community.

The Brotherhood of Our Lady played a notable role in the spiritual life of 's-Hertogenbosch. Equally influential, if not more so, was the role of the Brothers of the Common Life, exponents of the reformist movement, the Devotio Moderna, who had established a school in the city. The Brotherhood, founded by Geert Groote about a century before Bosch was launched on his career, had the approval of the Church authorities. Not long after Bosch was married, the young Erasmus became a pupil at the Brothers' school, where he passed some two unhappy years. In the school's library were books by St Augustine, St Ambrose, Thomas Aquinas, Jacopo di Voragine and others. It has been shown that Bosch was influenced by the writings of Jan van Ruysbroeck, the spiritual father of the movement; and it is safe to assume that a man of such rich learning as Bosch displayed in his pictures had acquired much from the Brothers or their school, the chief educational centre in the city.

A visionary and profoundly knowledgeable, ever curious and inventive, Bosch painted little that was ever predictable. His five greatest works, *The Seven Deadly Sins, The Hay Wain, The Adoration of the Magi, The Garden of Earthly Delights* and *The Temptation of St Anthony*, the first four of which were all owned by Philip II of Spain, are, if not wholly original in concept, at least unique in some important respects.

The Hay Wain and *The Seven Deadly Sins* are the most readily intelligible; the latter, an early work, was designed as a table top or cover to a font. The format, with its balanced grouping of roundels accompanied by scrolls, is unique; the quotations on the scrolls, from Deuteronomy, state a profoundly pessimistic view of man's fate. In the two roundels at the 'base' are Bosch's first depiction of hell and his only extant rendering of the heavenly Paradise. The seven deadly sins are shown in sections radiating from the all-seeing eye of God in the centre; they are illustrated with a pointed and sophisticated narrative skill.

Probably his first triptych, executed between 1490 and 1500, *The Hay Wain* describes the folly of man's ways that results from the Fall and Expulsion of Adam and Eve from the earthly paradise. Bosch uses a proverb – the world is a waggon of hay from which each man grabs what he can – to illustrate the vanity of man's earthly pursuits. The huge waggon is pulled inexorably to hell by monstrous devils. No one before had used a lay conceit in such a way or chosen to express such cynicism: Pope and Emperor lead the procession behind the waggon. The Angel of the Lord expels Adam and Eve from Paradise and the way to hell is henceforth predetermined, in spite of Christ's sacrifice.

In *The Adoration of the Magi*, painted for a donor and his wife, members of the Bronckhorst and Bosshuyse families, he draws attention to the ever-present power of evil in a unique way. At the entrance of the ruined stable is a strange bearded figure, who has recently been identified as the Jewish Messiah, Antichrist to Bosch's contemporaries, the last great opponent of Christianity before the Last Judgement and the end of time.

Antichrist and his followers inhabit the fallen hut of David, all that remains of the Old Law. His influence is not limited to his entourage; the shepherds on the roof are evil, as their looks suggest. The Magi too may be his adherents: they may also be the last three kings, who, prompted by Antichrist, would engage in the final war. On the reverse, Bosch depicted the *Mass of St Gregory*, during which the Passion of Christ was revealed to the saint. In this revelation, the suicide of Judas is included. Judas was the counterpart of Antichrist, and the inclusion of his death was as unusual in a rendering of the Passion as was that of Antichrist at the Epiphany, an event normally associated with joy.

The triumph of Christianity over the devil is the subject of the *Temptation of St Anthony*, a third, elaborate triptych painted perhaps a little earlier than the *Adoration of the Magi*. The story of the legendary founder of monasticism, who gave up his worldly possessions and withdrew to the desert in order to lead a life of piety, and was there tempted by the devil, was then well known. The figure of Christ, in the centre of the triptych, is small and not easy to make out; the saint kneels exhausted after his battle with sin; and it is on sin that the artist dwells. His inventiveness seems unending as he describes all its manifestations: each sin is translated into a repellent distorted figure or a grotesquely deformed animal.

In sharp contrast is *The Garden of Earthly Delights*, a triptych executed about 1504. This was the year in which the planets Sol (Sun) and Luna (Moon) joined in the house of Cancer; Bosch's subject is this astrological

phenomenon with all its religious consequences and connotations. The mystic associations between astrological concepts and Christianity had a long tradition, of which Jan van Ruysbroeck, the spiritual founder of the Brothers of the Common Life, was part. The union of the two planets typified the marriage of Christ with Ecclesia (the Church); that event takes place in the form of the marriage between Christ (Adam) and Eve (the church) in the earthly paradise depicted on the left-hand wing. The Church's paradise is populated by the children of the planets Luna and Venus (the latter associated with Eve). Under their influence man lives in a state of love and bliss. Hell is the opposite; under the negative influence of the two planets, drunkenness, debauchery and gluttony result.

The complex astrological imagery and the different layers of meaning that Bosch expresses have only recently been unravelled. The triptych is the greatest work of art to have been inspired by this whole area of medieval study and mysticism, for long considered of little relevance. No other artist in his time or since has attempted to depict a synthesis of this nature, a fact that underlines the artist's isolation from the main development of painting in his time.

Bosch's art reveals a new world to us, much of which still remains only dimly comprehensible. That this arcane culture should have inspired a genius of such rich inventiveness, the possessor of an agile hand, keen eye and understanding of man, is the key factor in the distinction of his art and foundation of his fame.

1. *Christic presented to the People*

Oil on panel. 29½ × 24in (75 × 61cm)

Pilate's palace is set in a Netherlandish town where the crescent flag of heresy is prominently displayed and draws a crowd which is unconcerned with the sad appearance of the scourged Christ. 'Crucify him' are the words in Latin that they utter; Pilate simply says, 'Ecce Homo'. In the left foreground two donors have been painted out; their words remain: 'Save us Christ the Redeemer'. It is probably an early work, and is usually dated between 1480 and 1485.

Frankfurt, Städelsches Kunstinstitut

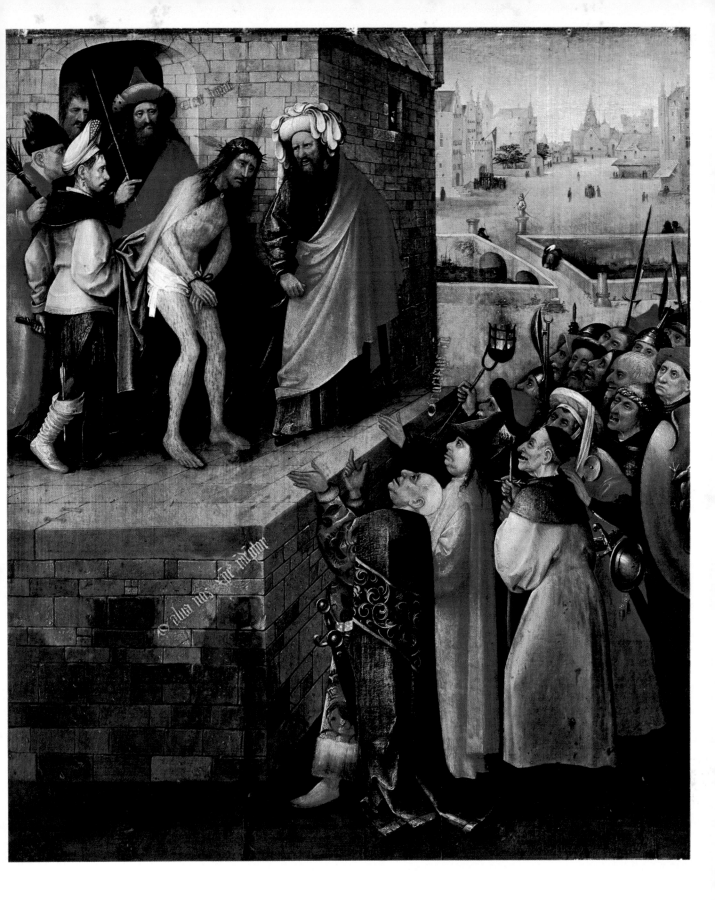

2. *The Seven Deadly Sins*

Oil on panel. $47\frac{1}{4} \times 59in$ ($120 \times 150cm$)

The status of the signature on this unusual work remains
uncertain. Generally considered to be an early work
(*c.*1475–80) by Bosch, *The Seven Deadly Sins* was in the
De Guevara collection in Brussels by 1520 and was
acquired by Philip II of Spain in 1570. The composition,
unique in Netherlandish painting, clearly resulted from a
specific commission, no knowledge of which survives.
One of Bosch's most explicit and didactic works, it is
liberally inscribed with explanatory quotations; those
on the scroll taken from Deuteronomy are given
particular emphasis ('For they are a nation void of
counsel, neither is there any understanding in them',
and 'I shall hide my face from them, I will see what their
end shall be') and set the theme for this masterpiece of
foreboding.

Madrid, Prado

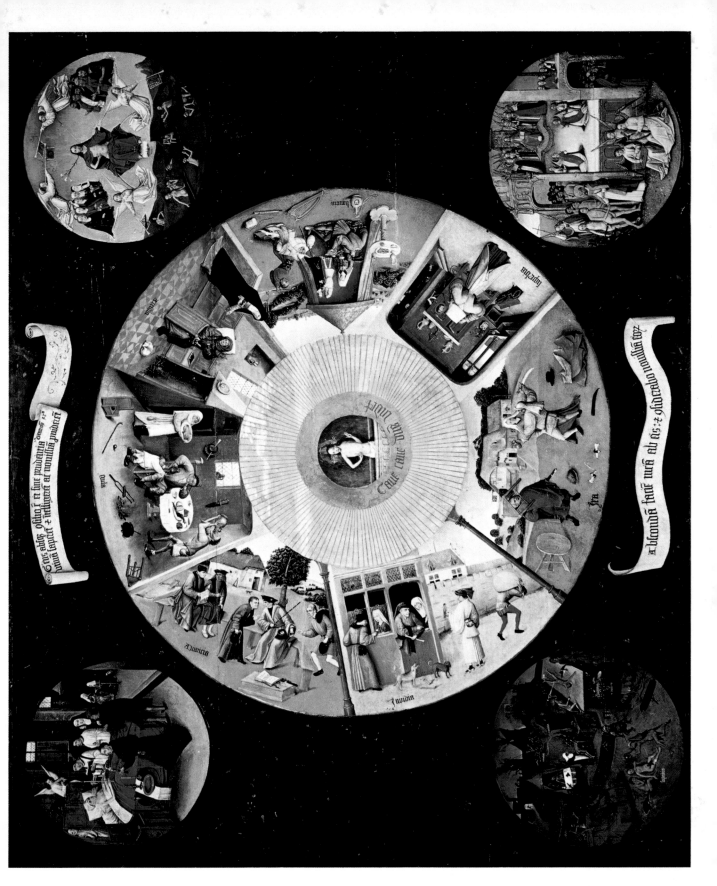

3. *The Seven Deadly Sins*

Detail

Death steals up from behind, as priest, acolyte, nun and monk gather to administer the last rites, and an angel and devil wait to fight over the dying man's soul in a shuttered bedchamber. The son watches, while in the adjoining chamber the wife counts her inheritance. The monk does not turn the crucifix to the dying man, but towards the spectator — a pointed reminder that the scene could also refer to his own last moments. Bosch shows himself more or less at ease when coping with the challenge of the spatial arrangement of figures in the interior, a problem that had provided a real challenge to Jan van Eyck some fifty years before. Probably aided either by illuminated manuscripts or near contemporary prints, Bosch is able to point a cruel comment on the inner thoughts of those soon to be bereaved.

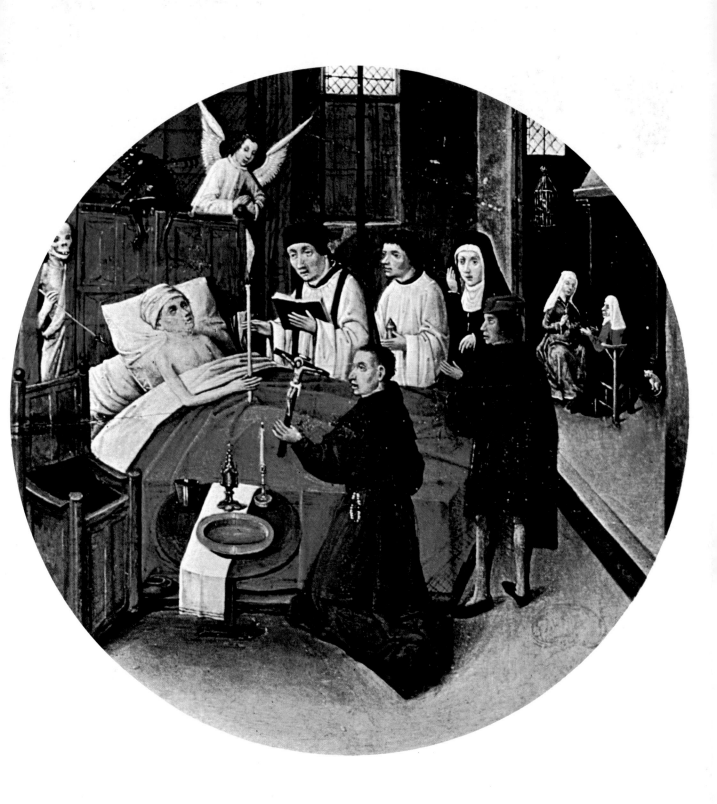

4. *The Marriage at Cana*

Oil on panel. 36½ × 28¼in (93 × 72cm)

This is generally thought to be an early work (executed between 1475 and 1480) and not in good condition; Bosch adds an element of mystery to a traditional rendering of Christ's first miracle when He turned water into wine. The acolyte who stands arm raised before the bridal couple, the musician on the makeshift gallery, the master of ceremonies standing before the display of fine metalwork, the servant stricken as the feast is brought in, all these are unusual and peculiar details that have as yet to receive convincing interpretation.

Rotterdam, Museum Boymans-van Beuningen

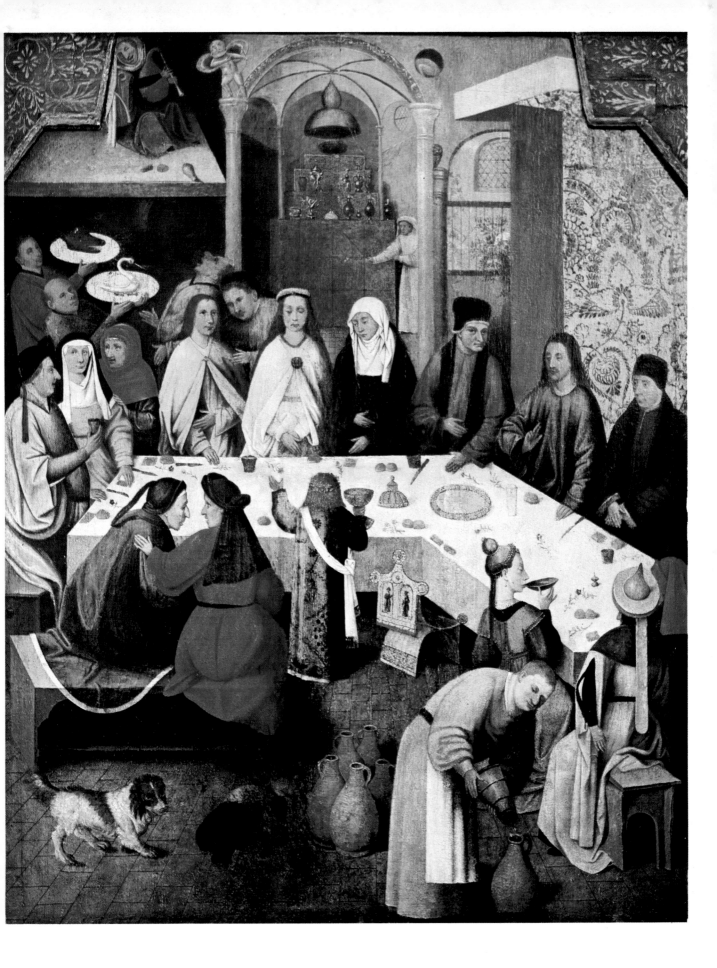

5. *The Cure of Folly*

Oil on panel. 19 × 13¾in (48 × 35cm)

This play on the medieval operation of cutting a stone out of a madman's head to cure him is not generally considered to be by Bosch, although it has a good claim to be among his earliest works, produced between 1475 and 1480. A depiction of the operation by Bosch was recorded in the dining room of the Bishop of Utrecht in 1524; it may have been the picture which was acquired by Philip II from the heirs of De Guevara in 1570. The present work is smaller and a flower rather than a stone is being removed. The inscription has been subject to numerous interpretations. It seems likely that the subject of the operation, Lubbert, is a fool and that both the witnesses to the operation, a monk and nun, condone the deceit performed by a charlatan. Lubbert believes that the stone is being cut from his head, whereas it is a type of flower whose name, it has been suggested, also meant money in contemporary argot.

Madrid, Prado

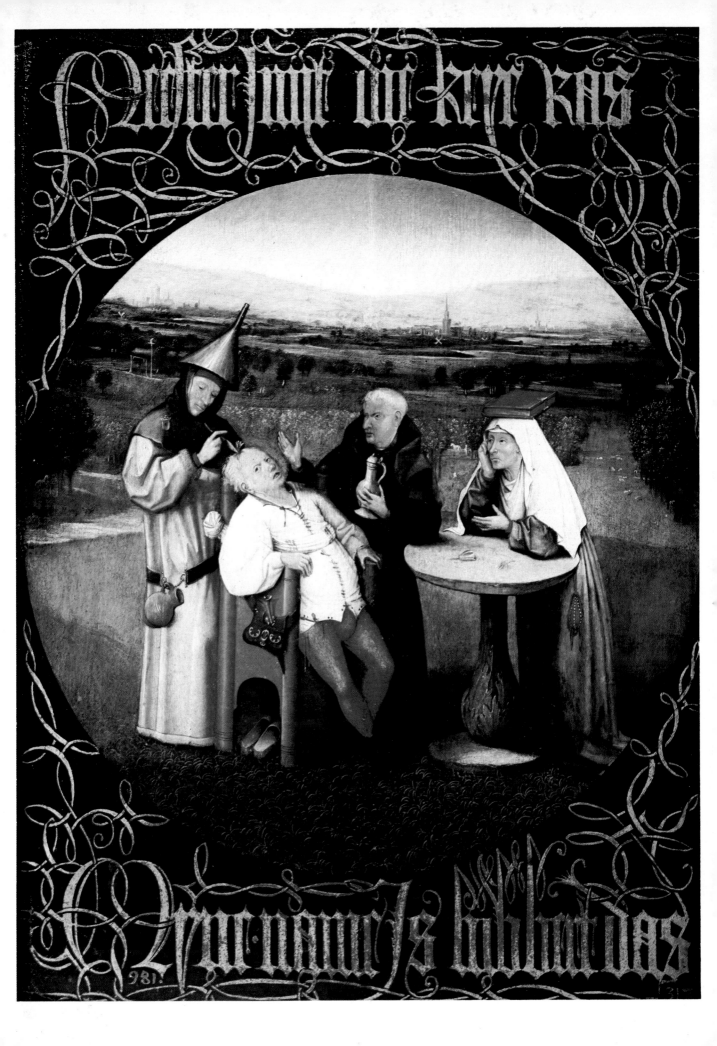

6. Christ on the Cross with the Virgin, St John, St Peter and the donor

Oil on panel. $27\frac{3}{4} \times 23\frac{1}{4}$in (70·5 × 59cm)

The Cross is set in a Netherlandish landscape; indeed the town has been identified as 's-Hertogenbosch itself. It is probably an early work executed between 1480 and 1485. Bosch has suppressed all his sense of fantasy to produce a solemn devotional picture.

Brussels, Musées Royaux des Beaux-Arts

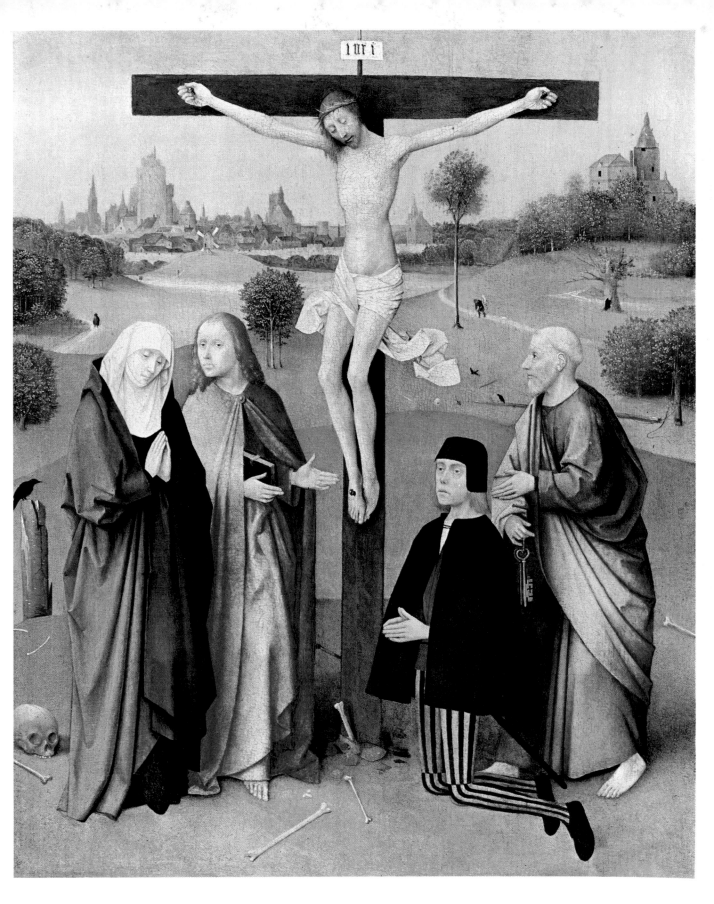

7. *The Death of the Miser*

Oil on panel. 36½ × 12in (92·6 × 30·8cm)

Generally dated *c*.1490–1500 as a work of Bosch's maturity, this death-bed scene has been thought to be a compartment of a larger work, with some justification if the narrow format and sharp recession of the composition are taken into account. (Against this is the existence of a fully worked up drawing, probably a *modello* for the present picture, which might suggest that this was intended as an independent, moralizing work.) Drawing on his earlier deathbed scene in the *Seven Deadly Sins* and contemporary prints illustrating the popular *Ars bene Moriendi*, Bosch shows the last moments of a man as death walks through the door; an angel implores Christ's intercession as a devil waits to gather the soul.

Washington DC, *National Gallery of Art*

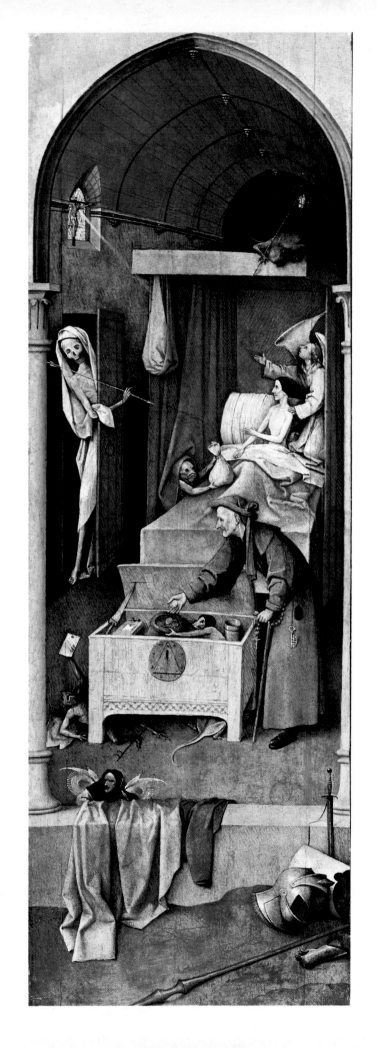

8. *Christic carrying the Cross*

Oil on panel. $22\frac{1}{2} \times 12\frac{1}{2}in$ (57 × 32cm)

Probably much cut down at the top, this fragment
dating from Bosch's early maturity (1490–1500) might
well have been the left-hand wing of an altarpiece, the
central compartment of which probably depicted the
Crucifixion. Christ staggers beneath His Cross surrounded
by a crowd of his persecutors. Below, the Good Thief is
prepared for his execution; he makes a last, agonized
confession to a complacent monk. The time has come
too for his companion; his cross is at his feet and he sees
clearly the place allotted for his execution on Calvary.

Vienna, Kunsthistorisches Museum

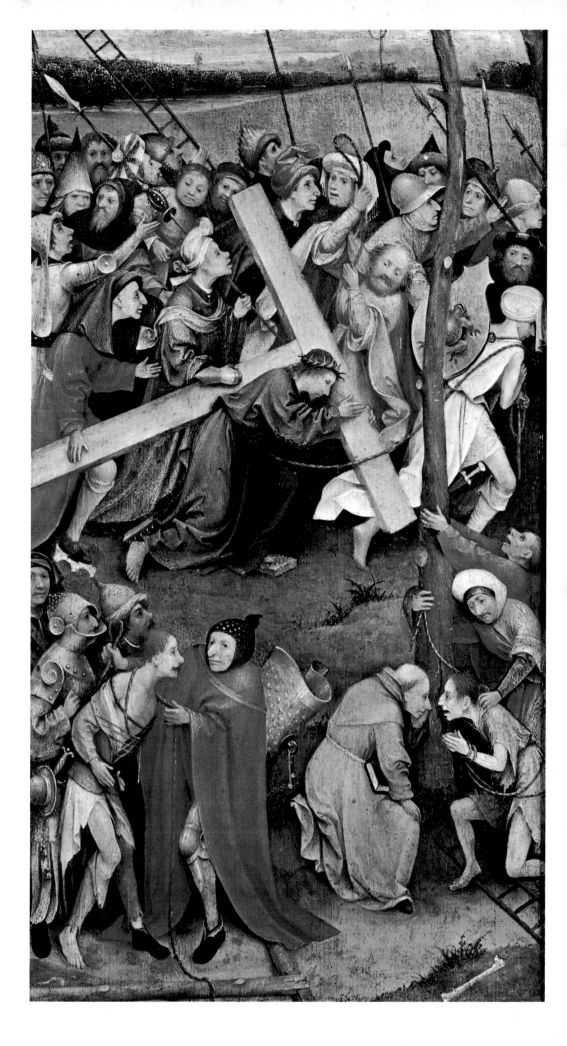

9. *The Ship of Fools*

Oil on panel. $22\frac{3}{4} \times 12\frac{1}{2}$in (57·9 × 32·6cm)

A work of Bosch's maturity, probably executed between 1490 and 1500, *The Ship of Fools* is clearly a satire whose precise meaning is obscure. A nun and monk are the chief characters in this crazy boating party. The masts have sprouted into trees and the company make merry, while their craft drifts. It is possible that Bosch was here inspired by a satirical poem by Sebastian Brant, *Das Narrenschiff* (The Ship of Fools), published in 1494, which relates how ships with fools set off to Narragonia, the land of folly.

Paris, Louvre

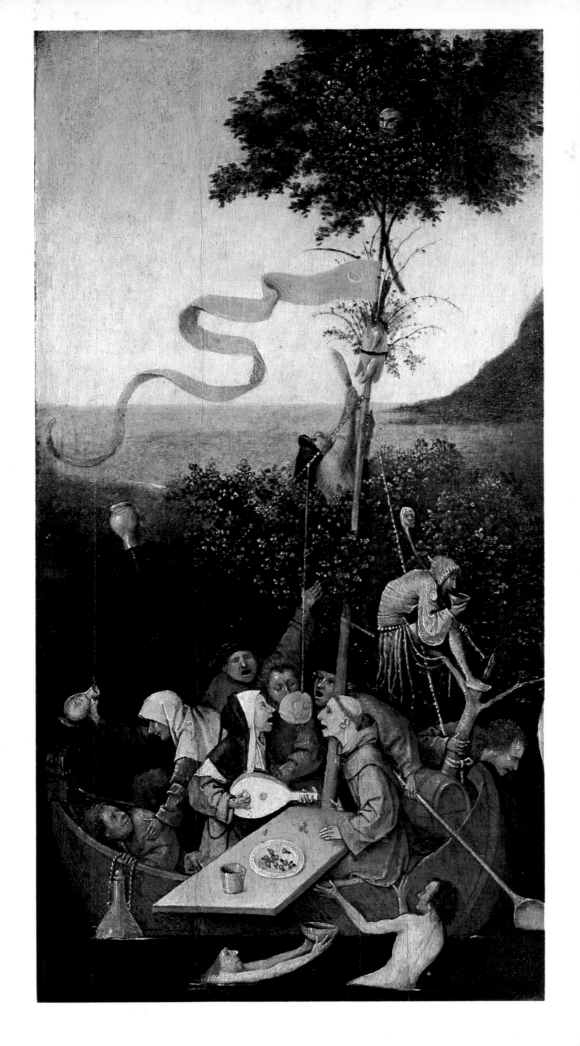

10. *The Hay Wain*

*Oil on panel. Central compartment 53 × 39¼in
(135 × 100cm); the wings 53 × 17¾in (135 × 45cm)*

This signed, fair-sized triptych, thought to be executed in about 1500, was, like *The Seven Deadly Sins*, recorded in the De Guevara collection not long after Bosch's death and was subsequently acquired by Philip II of Spain in 1570. It is the first painting in the Netherlands to combine a lay proverb with religious themes, and contains Bosch's first fully developed concept of Hell, for which he was to gain early fame and a lasting reputation. The reverse side of the wings shows a poor wayfarer; by his scale, he dominates the painted area as he walks a lonely path through the countryside; behind him a man is about to be killed by brigands, and peasants make merry in a meadow. Bosch's message here is more or less existential; he describes the vanity of earthly pursuits that are bound to result in perdition.

Madrid, Prado

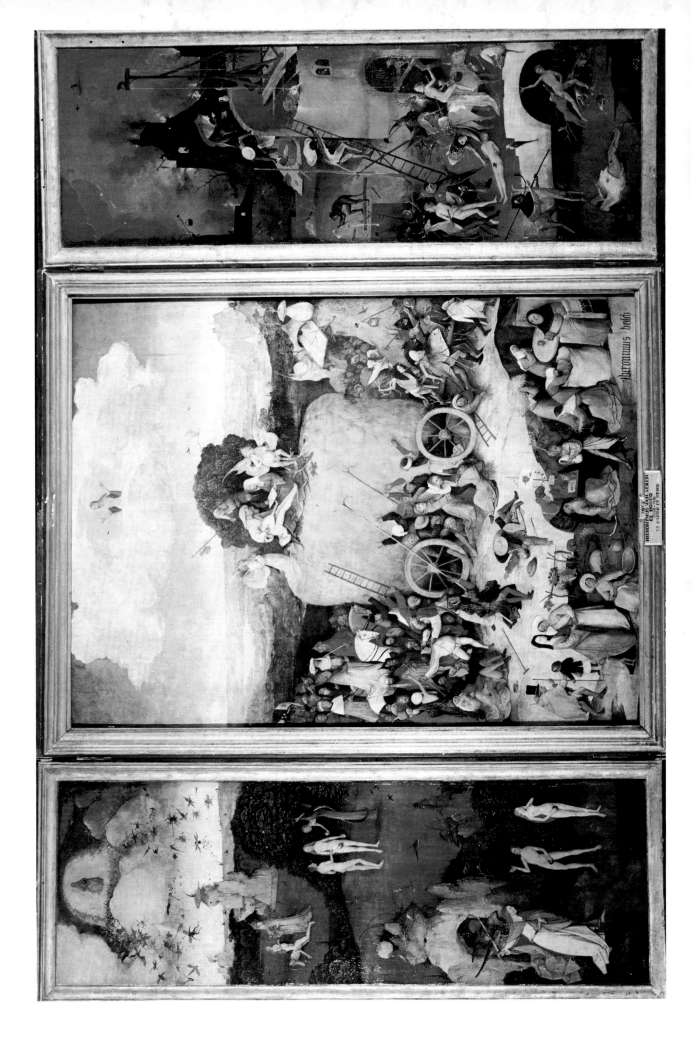

11. *The Hay Wain*

Central compartment

The world is a waggon of hay, each one grabs what he
can of it – this is the proverb which Bosch spells out
with great subtlety of vision and understanding. He uses
the proverb to portray life's vanity and the inexorable
results of human ambition in great detail and with an
incredibly wide and deep comprehension. Here is an
allegory of life full of pessimism, complete both in
totality and detail.

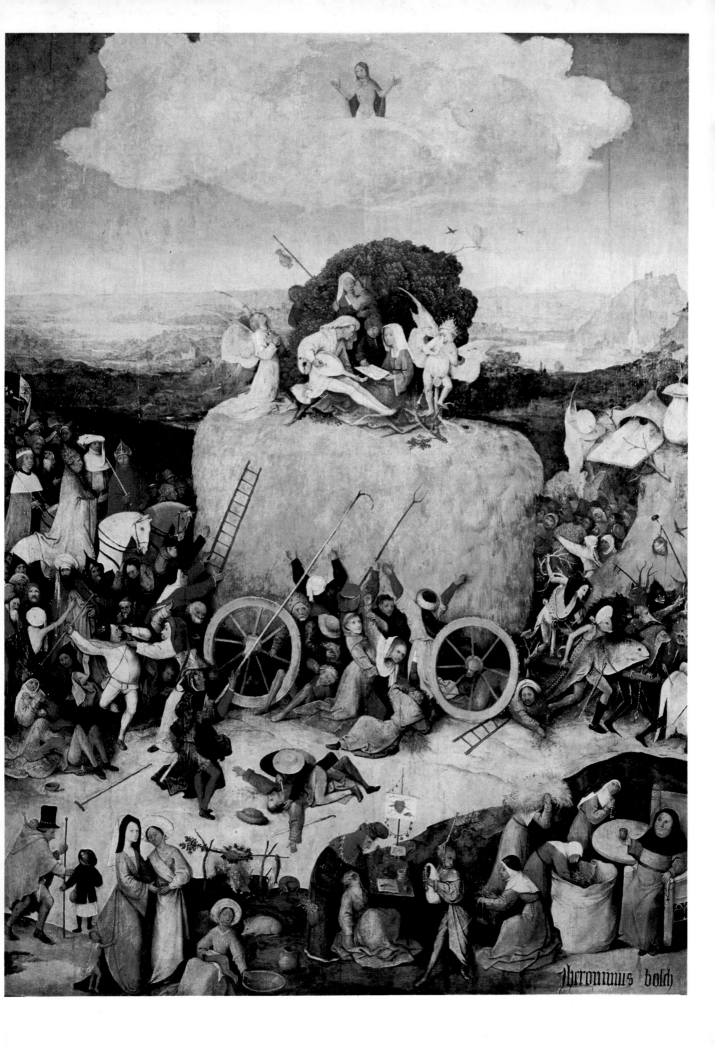

12. *The Hay Wain*

Detail of central compartment

Emperor and Pope lead the procession that follows the
waggon of hay into Hell; they are dignified and at one
with each other, unlike the throng in front of them who
fight and grapple for a handful of the load.

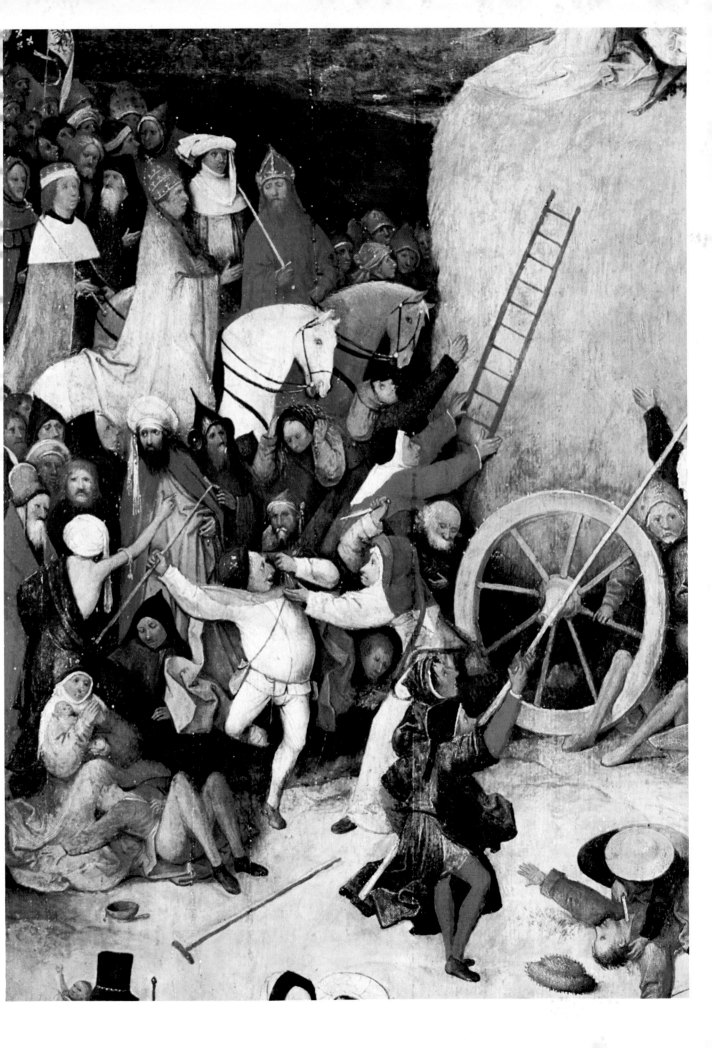

13. *The Hay Wain*

Left wing: The Expulsion of Adam and Eve
Right wing: Hell

Above the Garden of Eden is the Fall of the Rebel Angels who tumble onto the terrain on the horizon beyond the confines of a wood-lined Garden of Eden. In the distance God creates Eve; in the middle ground is the Temptation and in the foreground, in front of a rocky exit, the Angel expels a horror-struck, shameful Adam and Eve. Above the exit to Earthly Paradise is an unnatural growth of vegetation with over-ripe fruit that attracts birds, a symbol of sin.

Lucifer and the rebel angels fall to populate Hell, depicted by Bosch in the right-hand wing. They are busy at work building its macabre quarters, as doomed souls are hustled in, by the personifications of their sins, to suffer appropriate torture and eternal punishment.

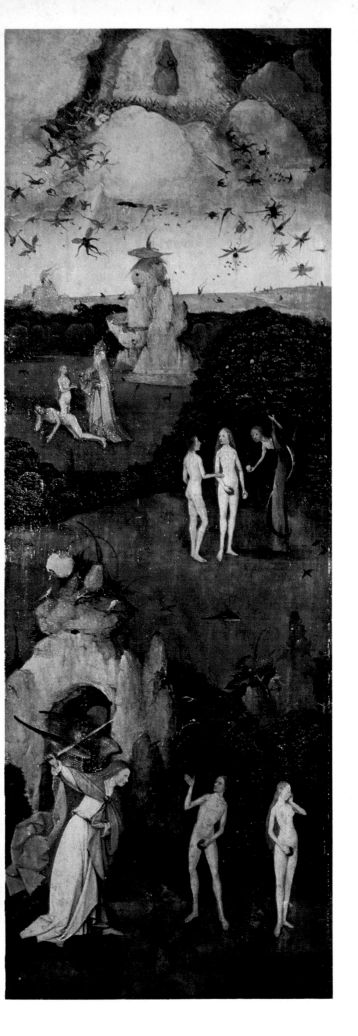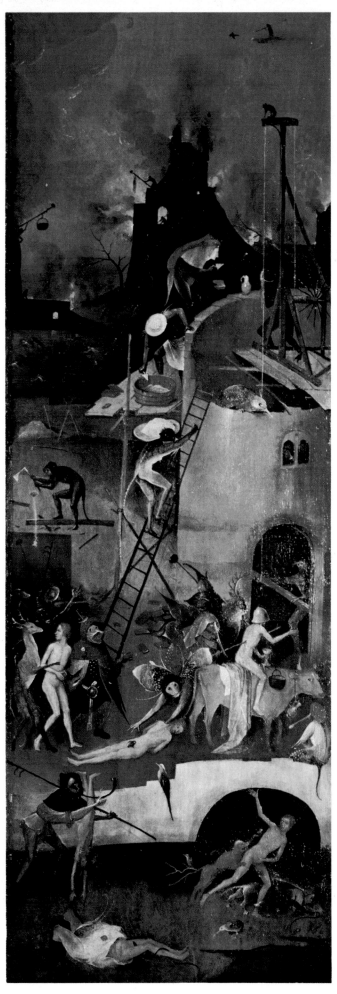

14. *The Hay Wain*

Detail of right wing

Against a background of Hell's fire, the devils are hastily
completing a tower of torture to receive the doomed
souls following the waggon of hay to Hell. Bosch's
demonic bricklayers mimic those who must have been
an everyday sight in 's-Hertogenbosch; Hell is depicted
as a living reality.

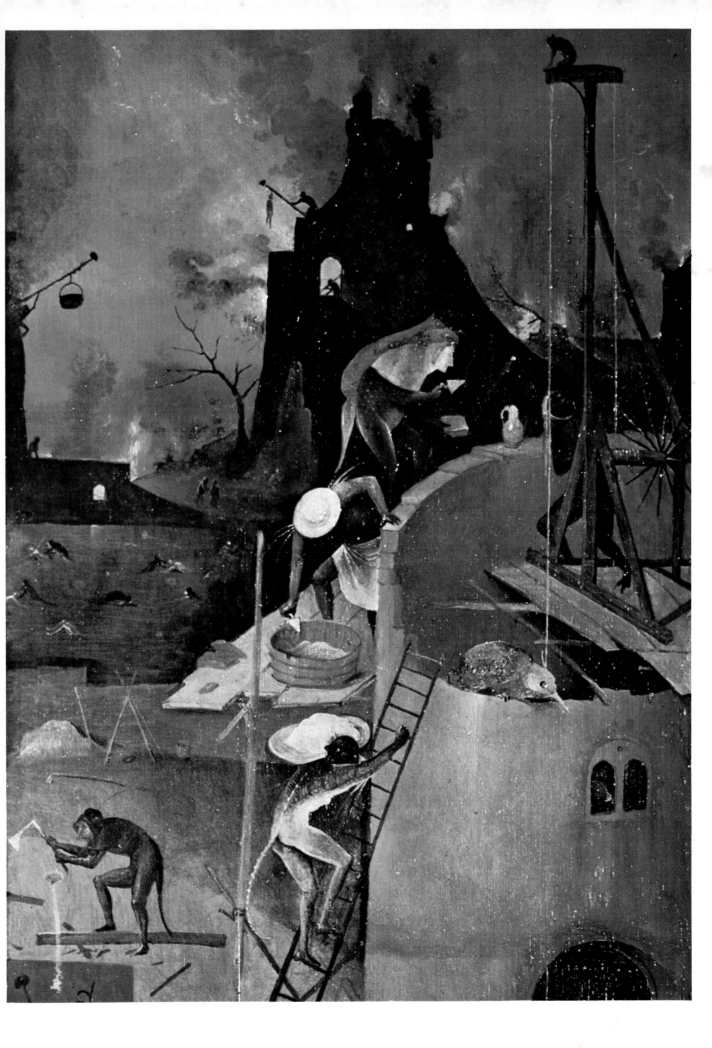

15. *St John on Patmos*

Oil on panel. 24¾ × 17in (63 × 43·3cm)

The Virgin and Child on a sickle moon appear, through the mediation of an angel, to the youthful St John as he writes the Book of Revelations. For Bosch, the island of Patmos, the traditional setting for the scene, is a hillside set above a Netherlandish estuary. There are traces of a signature on this work, probably executed not long after 1500, in which Bosch reveals his love of landscape panoramas and a playful side of his character. The evil spirit has tried to steal that ink pot which is guarded by an eagle, the saint's emblem. On the reverse, Christ's Passion is depicted in a roundel that recalls the format of *The Seven Deadly Sins* (*plate 2*); in the centre is a pelican feeding its young with its blood, a symbol of Christ's redemption of mankind.

Berlin, Staatliche Museen Preussischer Kulturbesitz

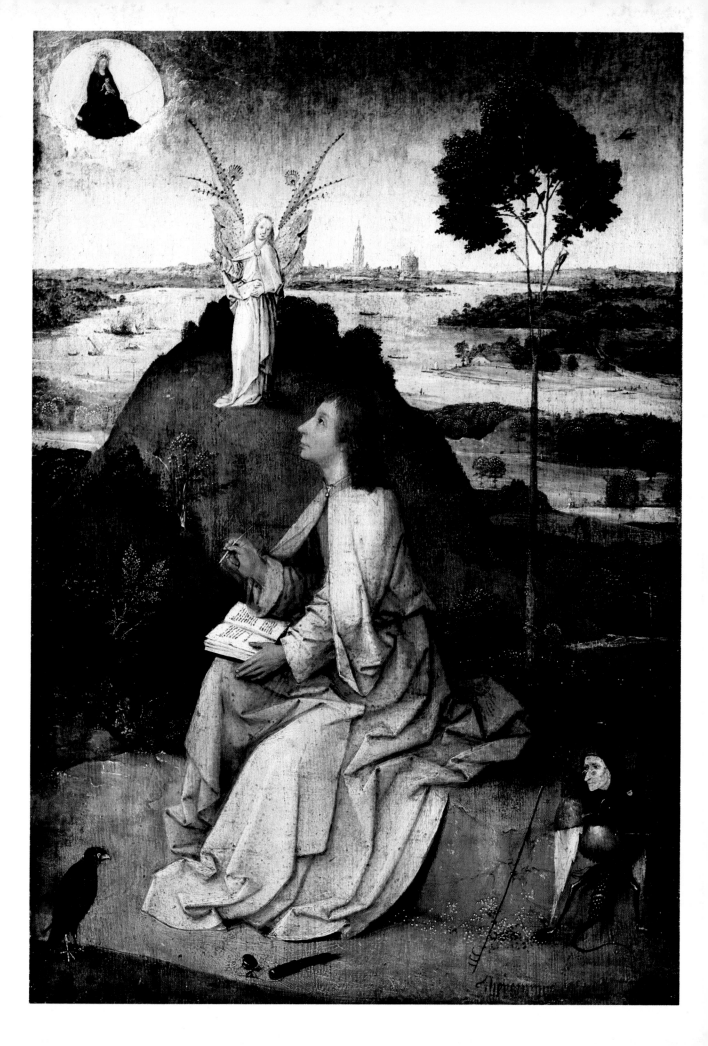

16. *The Martyrdom of St Ontcommer*

Central compartment of a triptych. Oil on panel.
41 × 24in (104 × 63cm)

Until recently the saint depicted in this painting was identified as St Julia. St Ontcommer, or St Liberata, was punished by her pagan father for having prayed for, and obtained, a beard in order to remain a virgin. Her cult originated in the southern Netherlands; there are records of an altarpiece dedicated to her in the cathedral of 's-Hertogenbosch, in which the saint, as here, was painted beardless. Signed and probably executed not long after 1500, this altarpiece has suffered a good deal over time, particularly the wings which originally showed two donors.

Venice, Palazzo Ducale

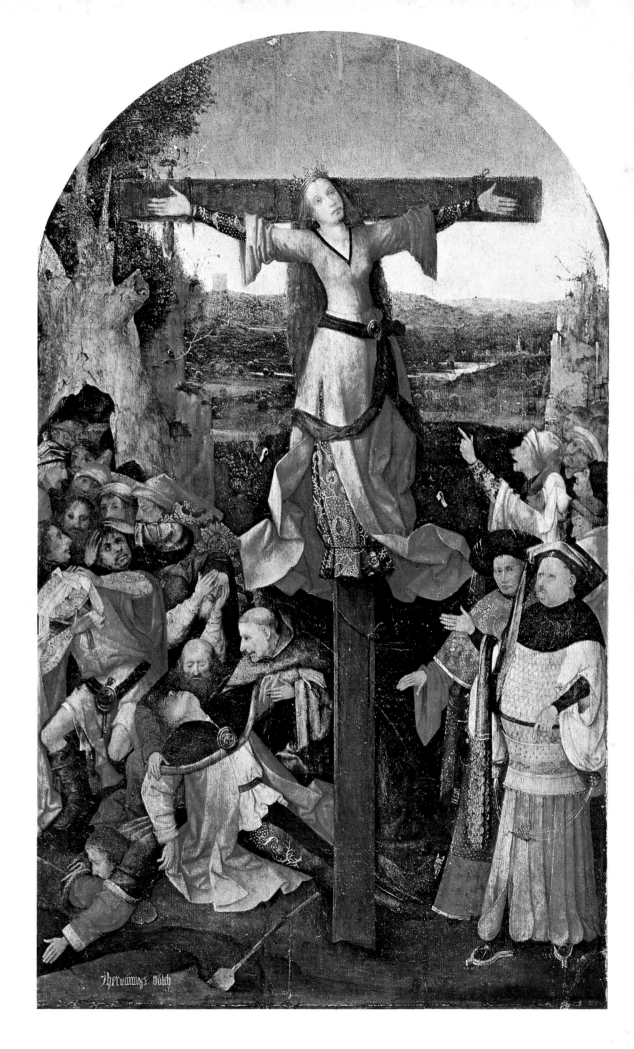

17. *The Garden of Earthly Delights*

Oil on panel. Central compartment 86½ × 76¾in
(220 × 195cm); the wings 86½ × 38¼in (220 × 97cm)

This masterpiece by Bosch, one of the most extraordinary
paintings in the history of art, is first recorded in the
collection of Don Fernando, Prior of the Order of St John
and the natural son of the Duke of Alba, who died in
1595. It was among a shipment of pictures sent to
Philip II of Spain in 1593. Generally thought to be a
work of Bosch's maturity, the triptych may well have
been executed in or around 1504, when the two planets,
Sol and Luna, joined in the zodiacal house of Cancer, an
astrological phenomenon that forms the basis of the
triptych's subject-matter, as has recently been
established.

Madrid, Prado

18. *The Garden of Earthly Delights*

Left wing: The Earthly Paradise

The extraordinary construction in pink coral has
recently been shown to be the astrological symbol of the
Crab, the emblem of the sign of Cancer. It is topped by a
crescent, the sign of the planet Luna, and contains a
circular opening at its base, the sign of the planet Sol.
Sol and Luna (Sun and Moon) are thus joined in
Cancer, a conjunction of both astrological and religious
significance that is the subject-matter of the triptych.
Christ stands in the foreground between Adam and Eve;
he holds Eve's hand in the gesture of the marriage
ceremony. Here Bosch depicts the marriage of Christ, as
the second Adam, with Eve as Ecclesia (the Church), a
union typified by the conjunction of the Moon
(Ecclesia) with the Sun (Christ) in the zodiac of Cancer.

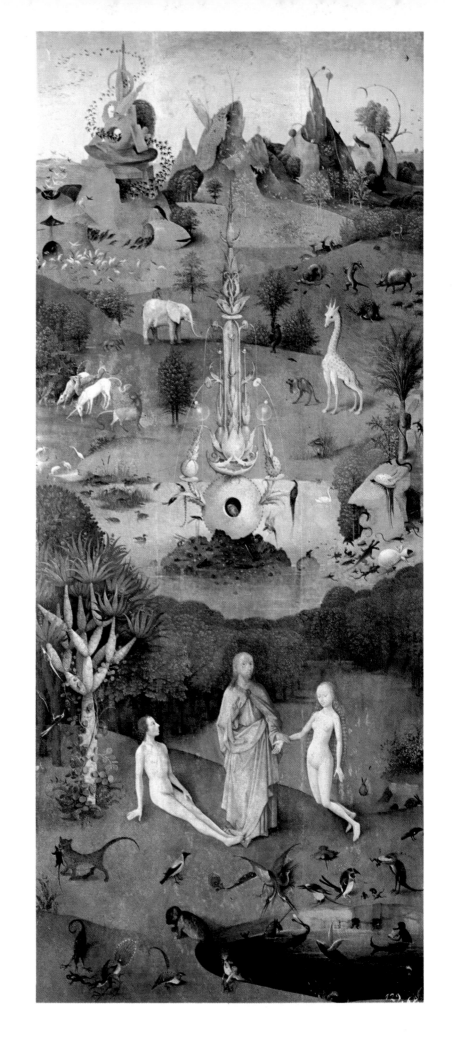

19. *The Garden of Earthly Delights*

Central compartment: Ecclesia's Paradise

The central compartment depicts Ecclesia's Paradise,
populated by the children of Venus, whom Bosch's
contemporaries identified with Eve. The symbol of the
astrological Moon is the blue globe that dominates the
visionary landscape, a Christian Garden of Love where
all is harmony under the influence of Venus and Luna,
the planets of love and maternity.

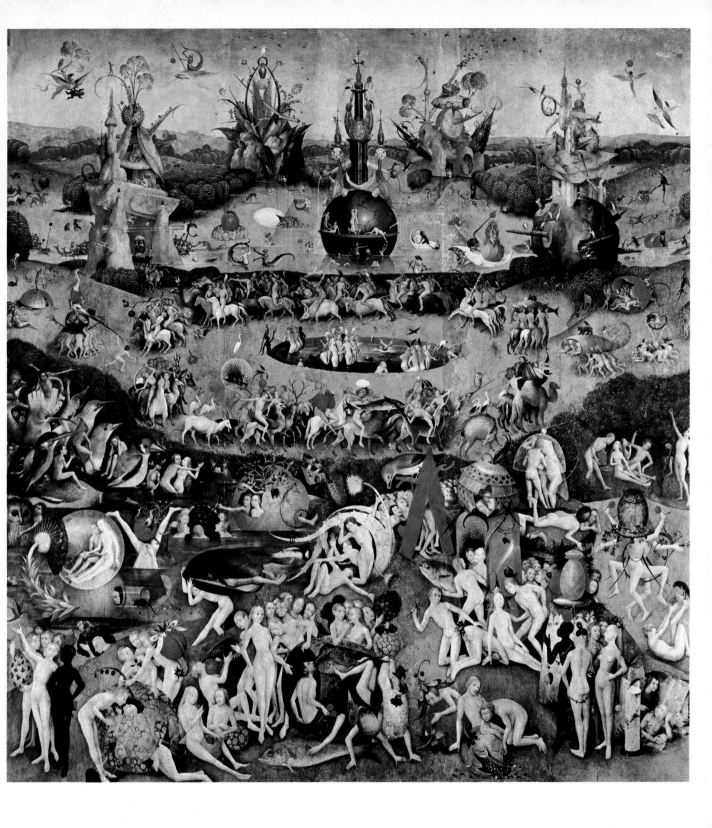

20. *The Garden of Earthly Delights*

Detail of central compartment

In the centre of Ecclesia's Paradise, beneath the sign
of Luna – the source of the four rivers – is the Pool of
Venus around which circles a cavalcade of animals and
monsters, symbols of the planets and constellations.
Bosch here celebrates the triumph of love under the
auspices of the two planets, Venus and Luna.

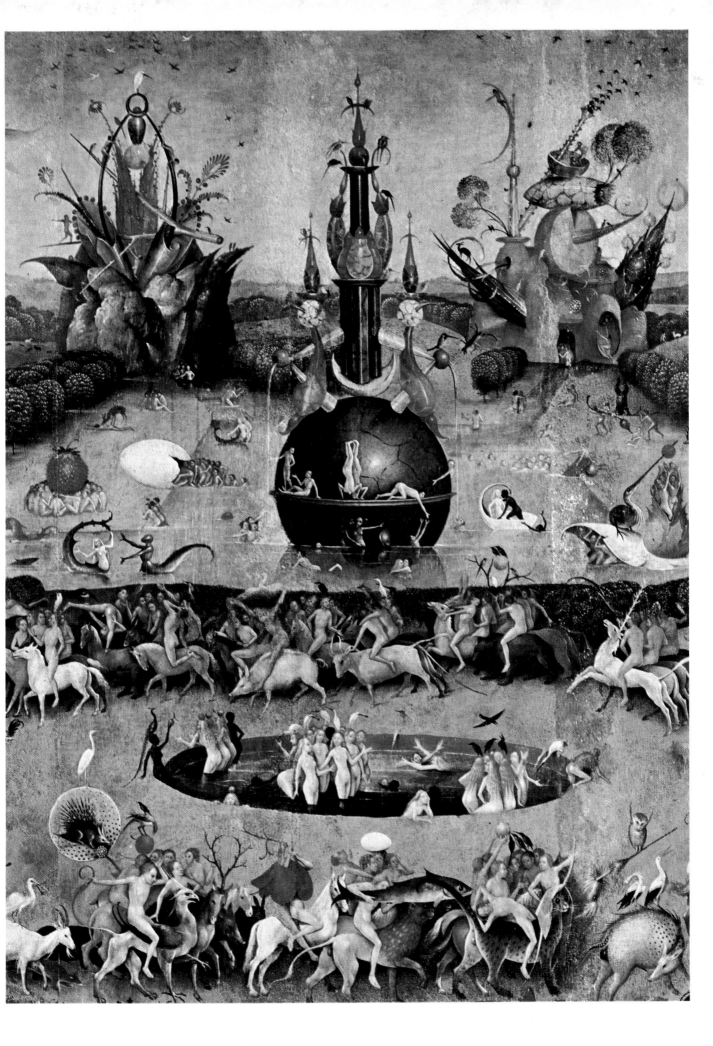

21. *The Garden of Earthly Delights*

Detail of central compartment

In Ecclesia's Paradise under the influence of the planets
Venus and Luna, a state of perfection is reached in
which opposites are resolved and harmony is obtained.
Nature is transcended and birds, for instance, are
depicted larger than humans, who under the influence of
the two planets are amorous and sometimes melancholic.

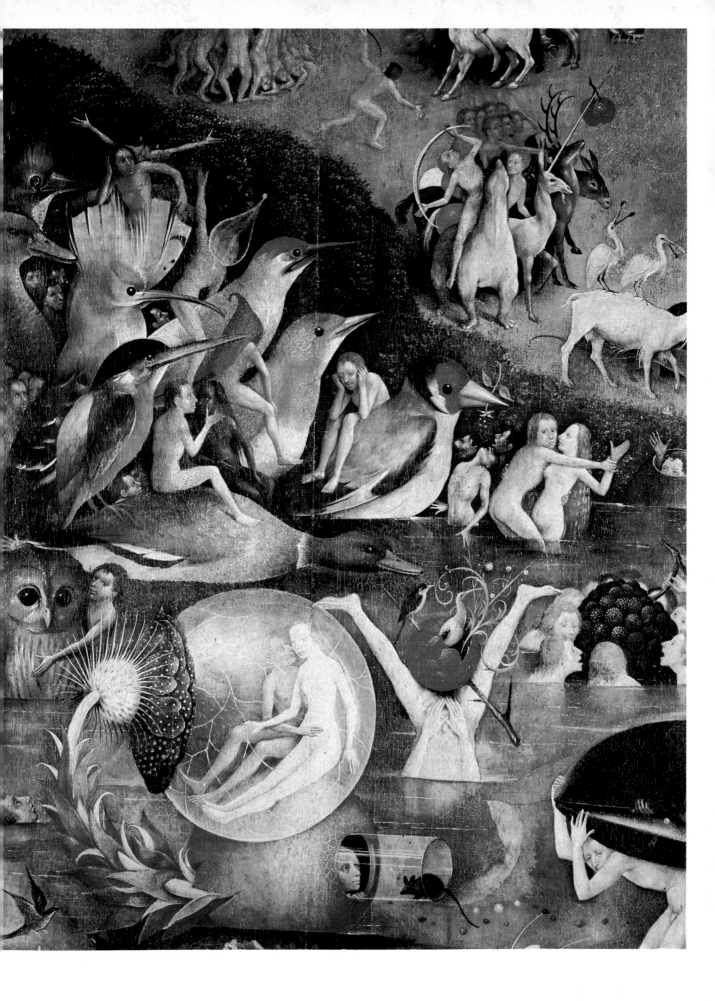

22. *The Garden of Earthly Delights*

Right wing: Hell

In Hell, Bosch depicts the negative influence of the planets, Luna and Venus. Prominent is the so-called 'tree-man', of which Bosch also made a drawing which shows him made up of symbols of Luna — bats, trees and eggs. The sins of debauchery, drunkenness, lechery and gluttony — the evil parallels of the virtues depicted in Ecclesia's Paradise — are punished in this demonic, astrological vision.

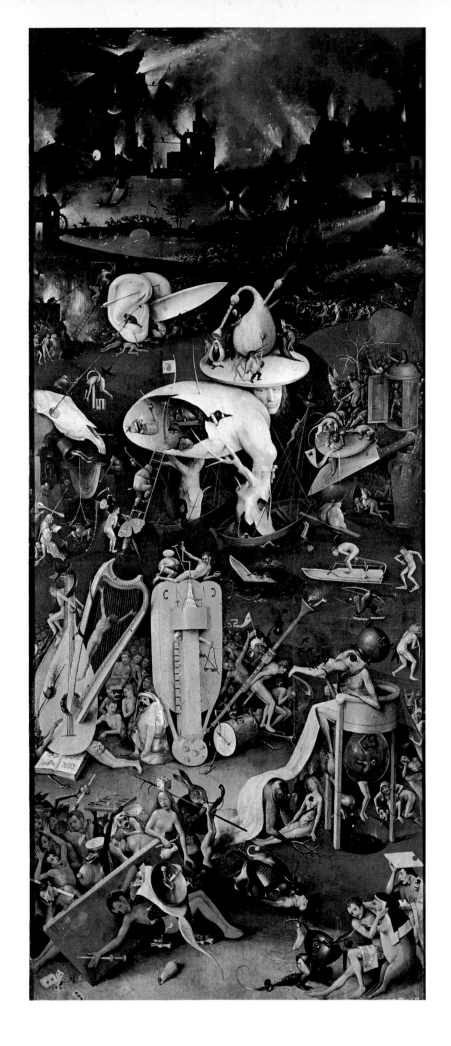

23. *The Garden of Earthly Delights*

Detail of right wing

The planet Venus is the protector of music and musicians. In Hell, under the adverse influence of the planet, souls are tortured on a guitar, a harp and an organistrum.

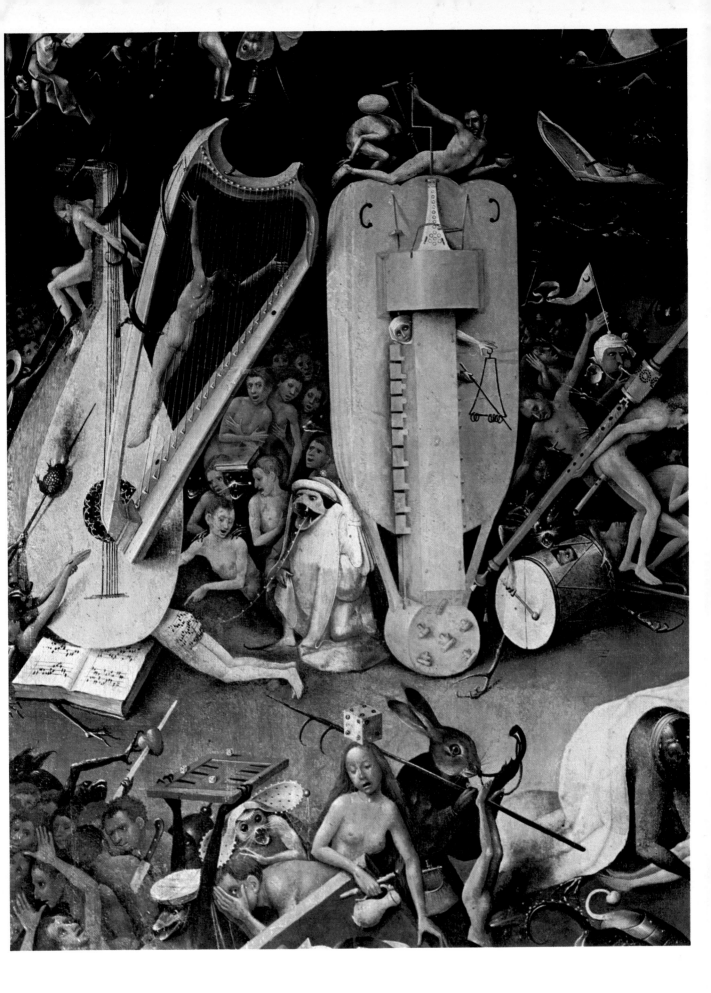

24. *The Garden of Earthly Delights*

The Shutters: The Creation of the World
Oil on panel. 86$\frac{1}{2}$ × 76$\frac{3}{4}$in (220 × 195cm)

Bosch depicts here the third day of Creation: the creation of the earth, flat and circular, surrounded by sea and set in a huge sphere. Vegetation has already appeared. Bosch is recorded as also having painted the fifth day of Creation (the creation of animals on the earth) on the outside of the shutters of the main altarpiece in 's-Hertogenbosch. The present work is the first pure landscape in the history of painting in the Netherlands. A subject rarely, if ever, treated by painters, it shows all the breadth and imaginative power of Bosch's genius.

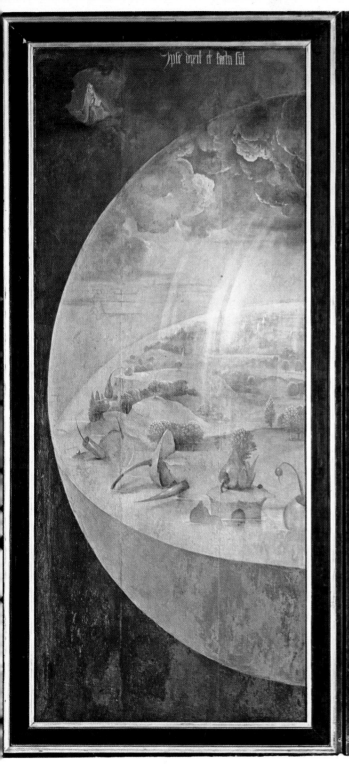
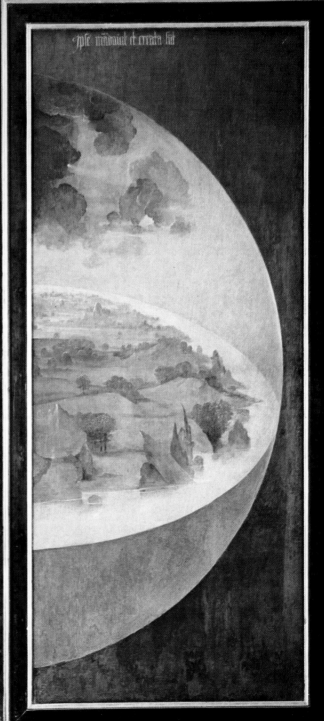

25. *St John the Baptist in the Wilderness*

Oil on panel. 19 × 15¾in (48·5 × 40cm)

St John reclines, dream-like, in a voluptuous wilderness. Beside him is an abnormal piece of vegetation; a bird pecks at its fruit. He points with lazy nonchalance, it seems, at a lamb nestling beneath a rock in front of him. Thus Bosch illustrates in this work, probably executed around 1505, the words of the Baptist, 'Behold the Lamb of God, which taketh away the sins of the world'. The unnatural, over-ripe weed contrasts sharply with the thin, sleek and tidy shape of the lamb, and no doubt Bosch, with his extraordinary vocabulary and vision, saw in it a symbol of the 'Sin of the world'.

Madrid, Museo Lázaro-Galdiano

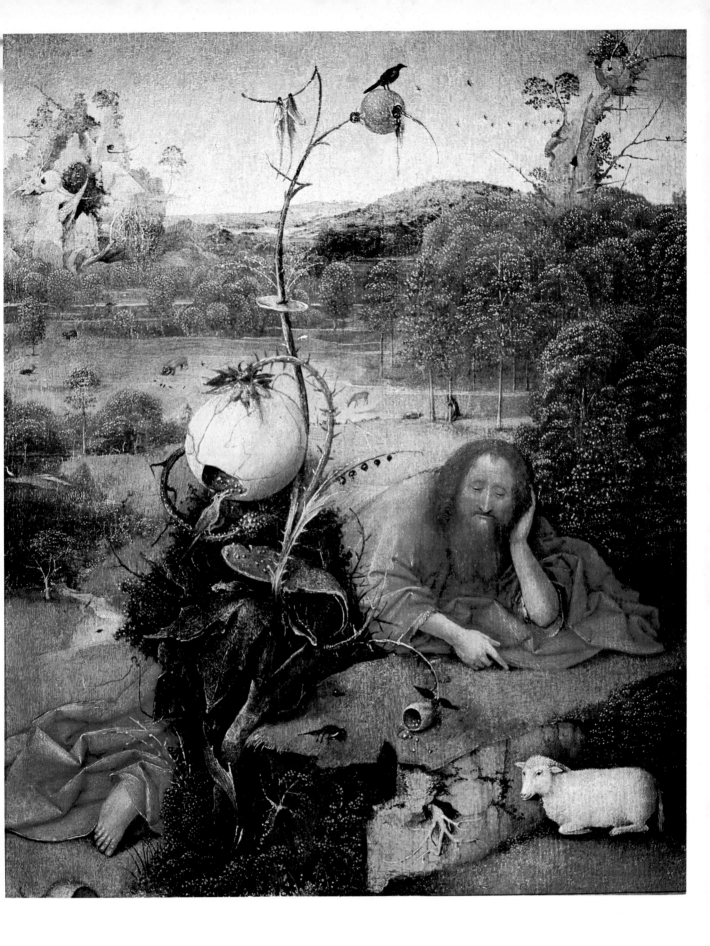

26. The Mocking of Christ

Oil on panel. 29 × 23¼in (73 × 59cm)

Christ appeals to the spectator with a look of pathos and
resignation as four of his persecutors crowd around him.
Two soldiers prepare to place the crown of thorns on his
head; their looks are sorrowful and one steadies Christ
by placing his hand on his shoulder. Beneath, two
Pharisees prepare him for what is to follow; one grabs at
his robe, the other clasps his hand with a mocking
gesture of friendship. The staves will soon be used to
thrust the crown of thorns more painfully onto Christ's
brow.

London, National Gallery

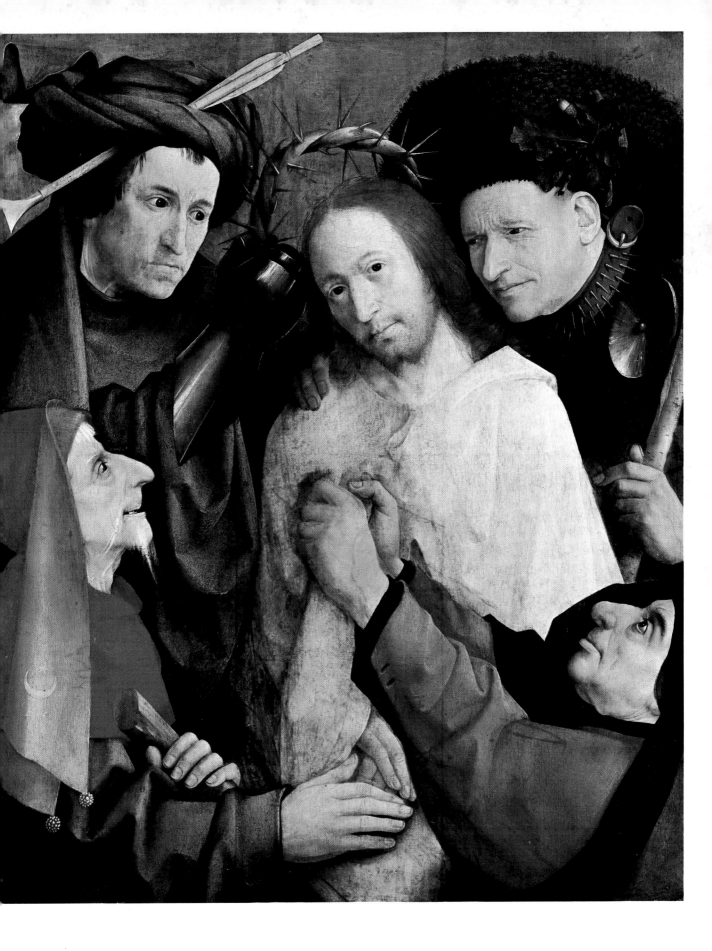

27. *The Adoration of the Magi*

Oil on panel. Central compartment $54\frac{1}{4} \times 28\frac{1}{4}$in
(138×72cm); the wings $54\frac{1}{4} \times 13$in (138×33cm)

The coats of arms of the two donors of this painting have
been identified as those of the Bronckhorst and Bosshuyse
families; the male donor's patron saint is St Peter, and his
wife's is St Agnes. The triptych was probably executed
for them in about 1510; in 1568 it was confiscated
from Jan van Cavembroot, near Brussels, by the Duke of
Alba and sent, six years later, to Philip II of Spain. This
masterpiece, in which Bosch displayed his talent as a
landscapist, has been the subject of a lengthy analysis in
which the forces of evil which surround the Virgin and
Child have been identified. Uniquely, Bosch includes in
the painting the Antichrist, and, as if to underline this
variation to a traditional theme, has borrowed the pose
of the Virgin and Child from a work executed some
seventy years earlier by Jan van Eyck.

Madrid, Prado

28. *The Adoration of the Magi*
Detail of left wing

The donor with his patron, St Peter, occupy the
foreground of the left hand wing; behind them is a
ruined palace, either King David's or King Solomon's, in
which St Joseph has had to take up quarters having
been displaced from the stable by the Antichrist. The
donor, although part of the scene, kneels in prayer, the
witness to this revelation of the Adoration. He would
have understood the added meaning that Bosch
introduced: that Christ, even at this moment of the
joyous recognition of his destiny, is protected only by his
mother from the evil that surrounds him, from which
St Joseph has had to retreat.

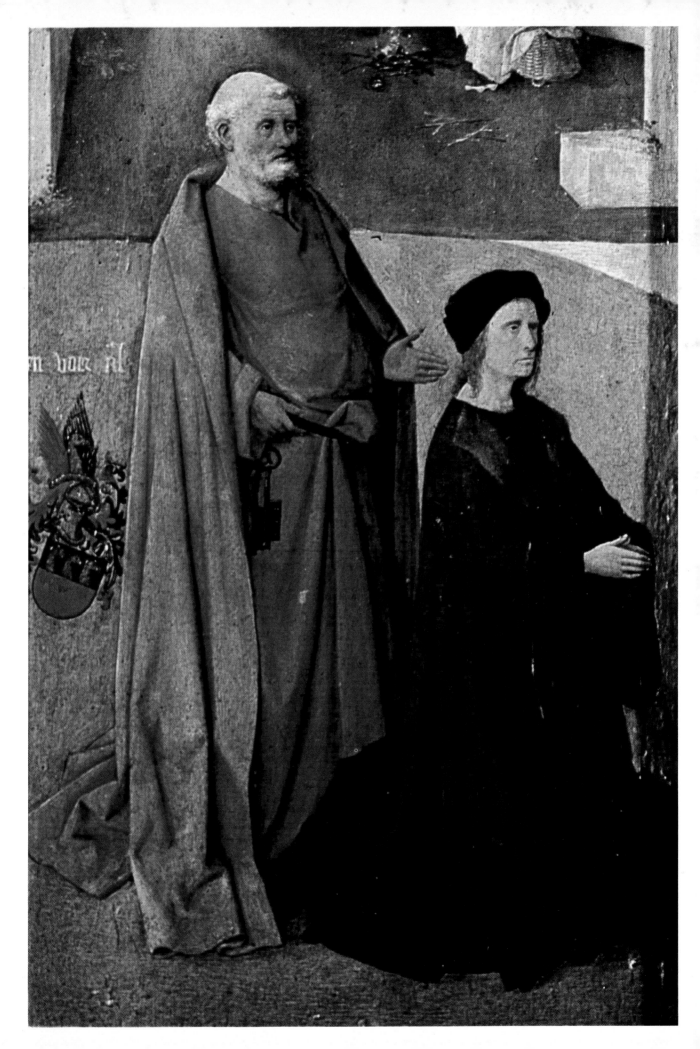

29. *The Adoration of the Magi*
Detail of central compartment

The three Kings have approached the Virgin and Child;
Balthasar kneels in prayer; his gift, a carving of the
sacrifice of Isaac, has been placed at the Virgin's feet.
Caspar kneels but looks alert and holds a half-covered
dish of bread, alluding, as does Balthasar's gift, to the
Mass. Caspar's robe is decorated with embroidery
showing the visit of the Queen of Sheba to Solomon,
while Melchior's gift of an orb topped by a pelican
(symbolizing Christ the Redeemer) is decorated with
three heroes bringing water to David; both scenes are
typological references to the Adoration of the Magi.
Caspar's crown is held by the strange half-naked figure
at the door of the stable, whose expression is by no
means respectful. This figure has been identified as the
Jewish Messiah, the Antichrist, whose companions lurk
inside the stable, a tumble-down hut which is a symbol
of the old Jewish faith. The Antichrist will try to deceive
mankind into believing that he is the Messiah and indeed
will seduce the three kings of the world at the end of
time. In his depiction of the three Magi, Bosch also
alludes to the three kings who will conduct the final war
before the Apocalypse.

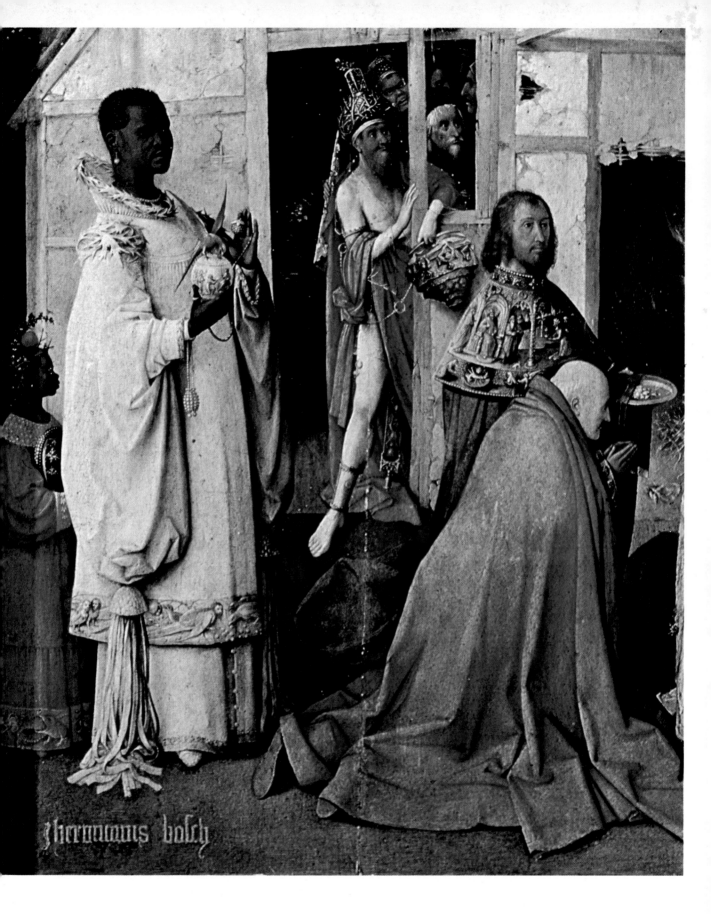

30. *The Adoration of the Magi*

Detail of central compartment

The Adoration of the Shepherds was not infrequently included with the Adoration of the Kings, although in the Bible they had been the first to recognize Christ's divinity. Bosch shows the Shepherds looking in at the scene from behind the Virgin and Child. Two have climbed on to the thatch, and a third scrambles up a tree to gain a similar vantage point. Their action brands them as evil; Bosch here illustrates Jesus' saying, 'Verily, verily I say unto you, he that entereth not by the door into the sheepfold, but climbeth up some other way, the same is a thief and a robber'. Behind is a bridge over a river through which an army, preparing for battle, is about to ford. This army, the retinue of one of the Magi, is also the army of the three kings which is about to engage in the final battle. Beyond, unconcerned, is a traveller with a mule; a monkey rides on the mule's back. This traditional component of the Magi's retinue wanders off, thus suggesting folly and sin.

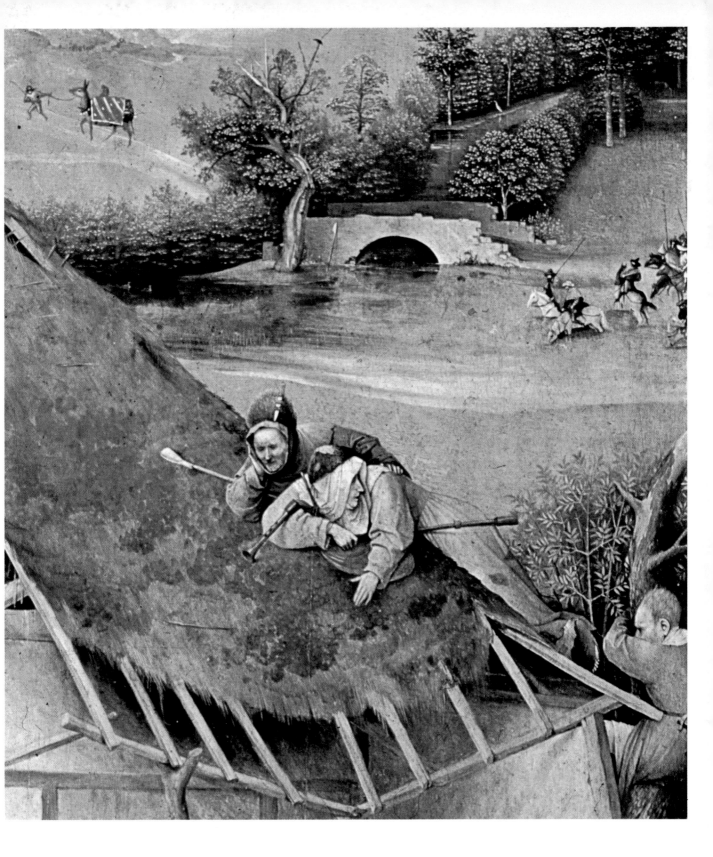

31. *The Vagabond*

Oil on panel. 28 × 27¾in (71 × 70·6cm)

The Vagabond is a late work, executed around 1510, and was perhaps cut down from the rectangular into its present octagonal shape in the seventeenth century. The theme also occurs on the outside of the shutters of *The Hay Wain*, and it has been suggested that the present work, in its original form, served a similar purpose. The subject remains obscure; traditionally it has been thought to represent the Prodigal Son, seen here returning to his father's house. In the middle distance is an inn of ill-repute and sin; perhaps the wayfarer is about to abandon lust for another sin, drunkenness. Certainly this is a lonely wanderer on life's path, and probably a man of pathos rather than a sinner.

Rotterdam, Museum Boymans-van Beuningen

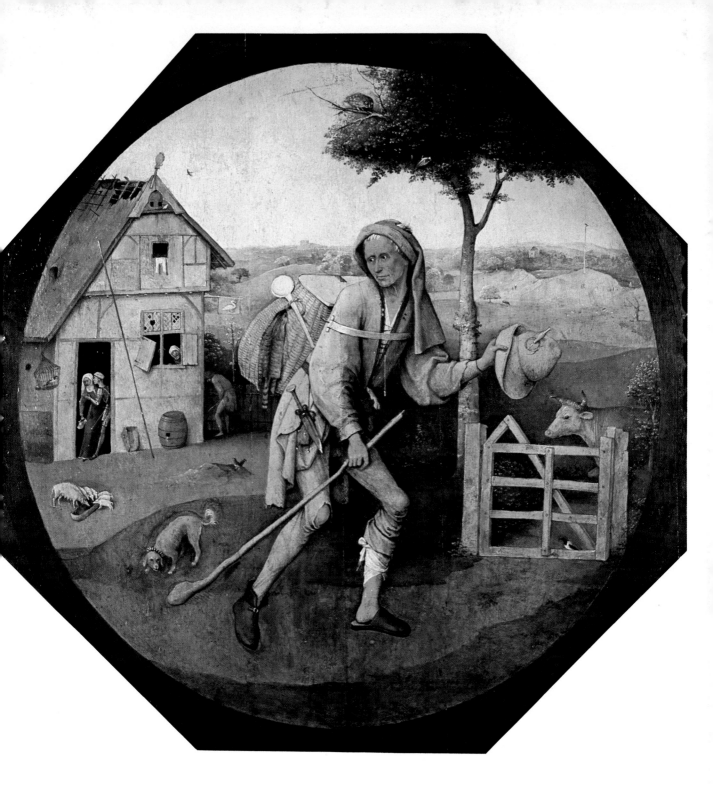

32. *The Temptation of St Anthony*

Left wing
Oil on panel. $51\frac{3}{4} \times 20\frac{3}{4}$in (131·5 × 53cm)

St Anthony is helped back to his cell by three
companions, unconscious after his elevation and beating
by devils which is depicted by Bosch in the sky above.
Bosch does not follow exactly the story of the ascetic's
return after his torment, but such deviation seems of
little importance when account is taken of the whole
concept of Bosch's manner of visualizing the temptations
of the saint. In this wing they are expressed by the
strange building constructed round the man on all fours,
the grotesque figures that approach it, the two weird
beings behind the saint and the monstrous bird skating
in the foreground. The paper which the latter carries in
his beak has an inscription on it which, translated, means
'lazy'; the creature therefore represents the sin of sloth.

Lisbon, Museu Nacional de Arte Antiga

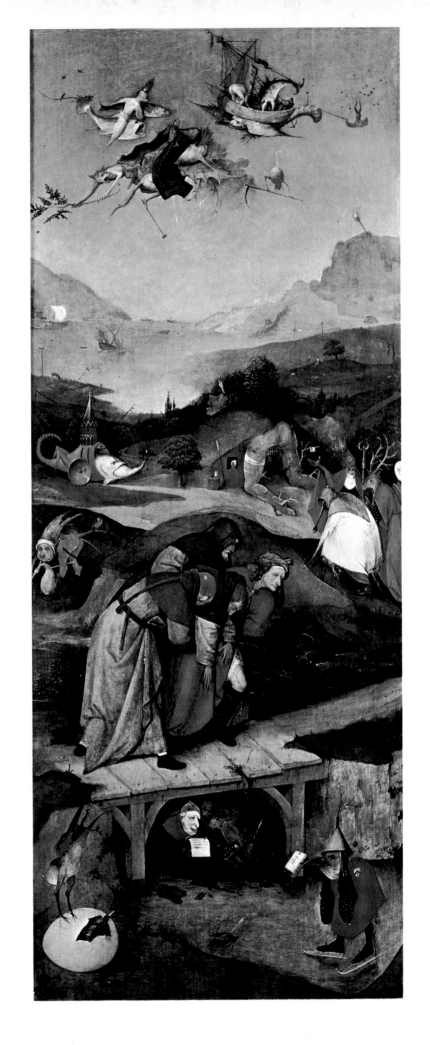

33. *The Temptation of St Anthony*

Right wing
Oil on panel. $51\frac{3}{4} \times 20\frac{3}{4}$ in (131·5 × 53cm)

The Saint is depicted meditating in a landscape as various temptations appear to seduce him. Gluttony and riotous living are the temptations represented by the weird scene round the table in the foreground; lust and fornication are the sins provoked by the woman who stands seductively in a makeshift tent. No satisfactory explanation has been provided for the drama before the city walls enacted in the background.

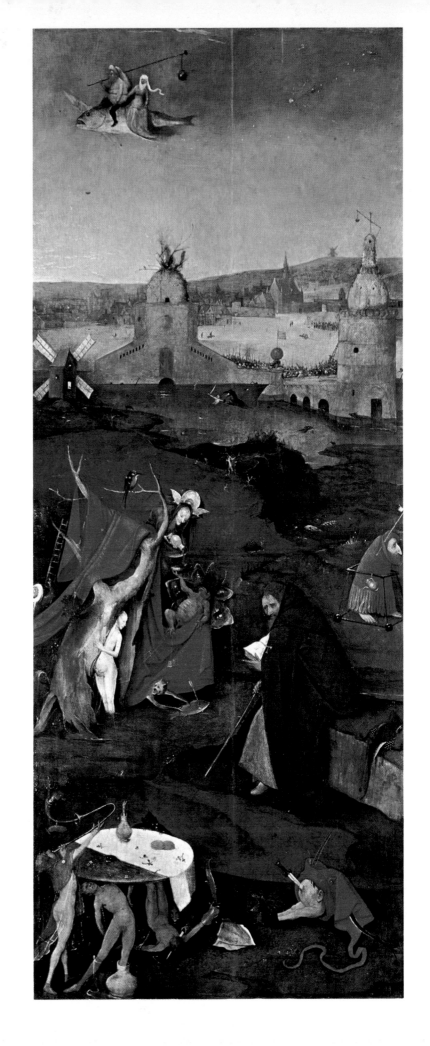

34. *The Temptation of St Anthony*

Central compartment
Oil on panel. 51¾ × 46¾in (131·5 × 119cm)

The central compartment depicts the saint, still
surrounded by temptation, but triumphant. He kneels
before the altar of the ruined chapel and turns to bless
the spectator as the risen Christ appears. The early
history of this extraordinary triptych is not certain;
the central compartment is signed and the work
probably dates from around 1510.

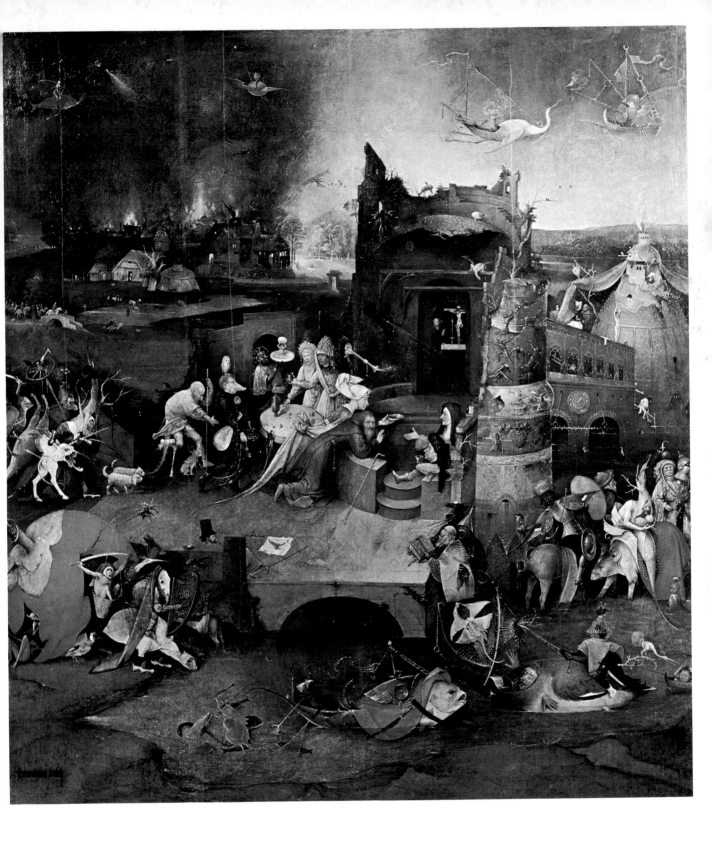

35. *The Temptation of St Anthony*

Detail of central compartment

Devils scurry about the ceiling of St Anthony's ruined chapel. The saint is surrounded by a weird band who try to disturb him in his prayers. Exotic gamblers set their game; a lavishly dressed woman play-acts the taking of communion with a nun nearby.

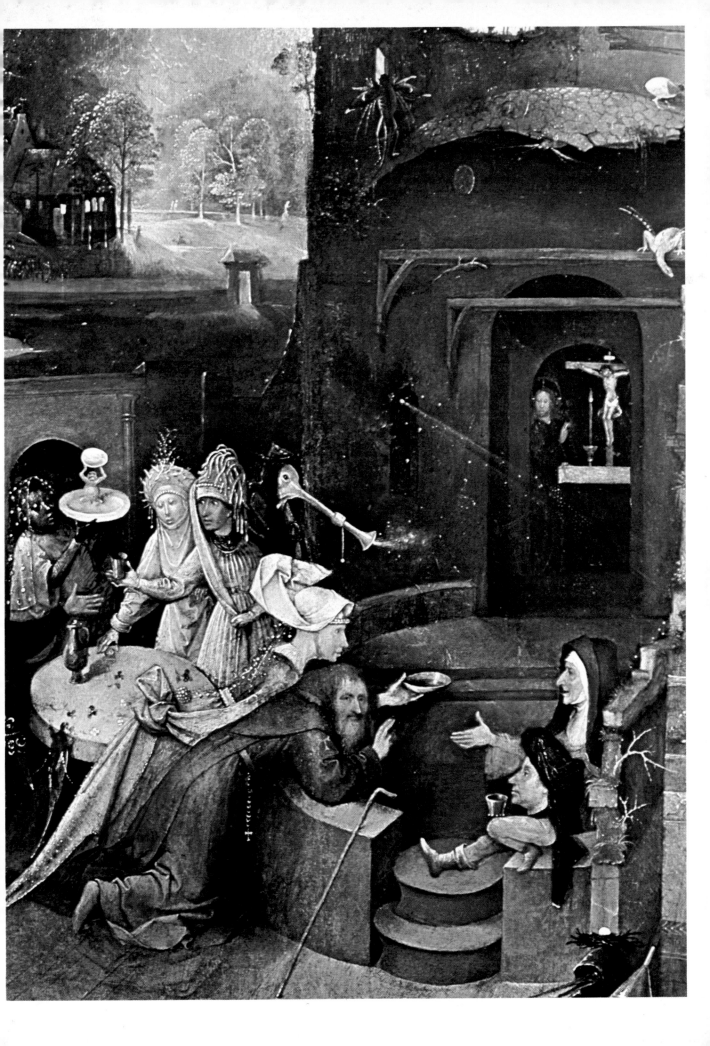

36. *The Temptation of St Anthony*

Detail of central compartment

Another cavalcade of evil spirits is about to burst upon the saint. The presence and variety of evil is endless, and Bosch determines that there should be no let-up for the saint in his struggle against temptation, even when Christ appears to vindicate his faith. In the background a village burns at night; the Apocalypse is about to occur; an army waits to engage in the final battle, as villagers still go about their work unaware of their fate.

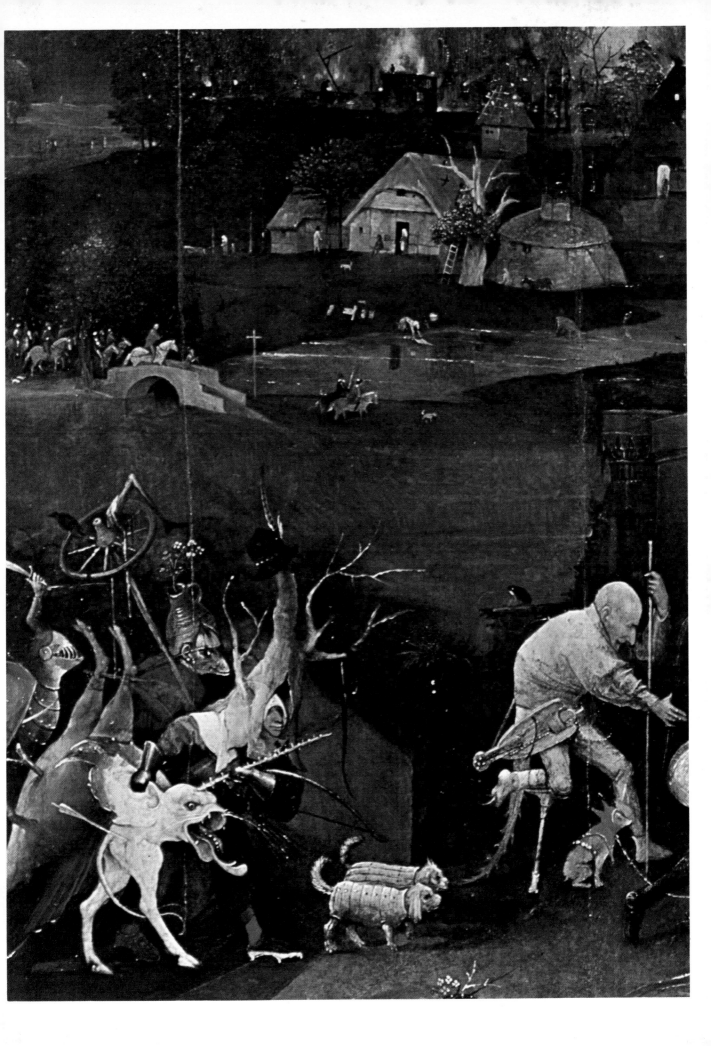

37. *The Temptation of St Anthony*

Left shutter: The Taking of Christ
Oil on panel. $51\frac{3}{4} \times 20\frac{3}{4}$in ($131 \cdot 5 \times 53cm$)

This scene from Christ's Passion, and that of the
following plate, are related with telling drama and
realism which sharply contrasts with the esoteric flights
of fancy on the inside of the triptych. Christ's captors
look triumphant; an apostle, perhaps Judas, slips off to
the left of the painting, as St Peter is about to cut off the
ear of one of the men who had come to arrest Jesus.

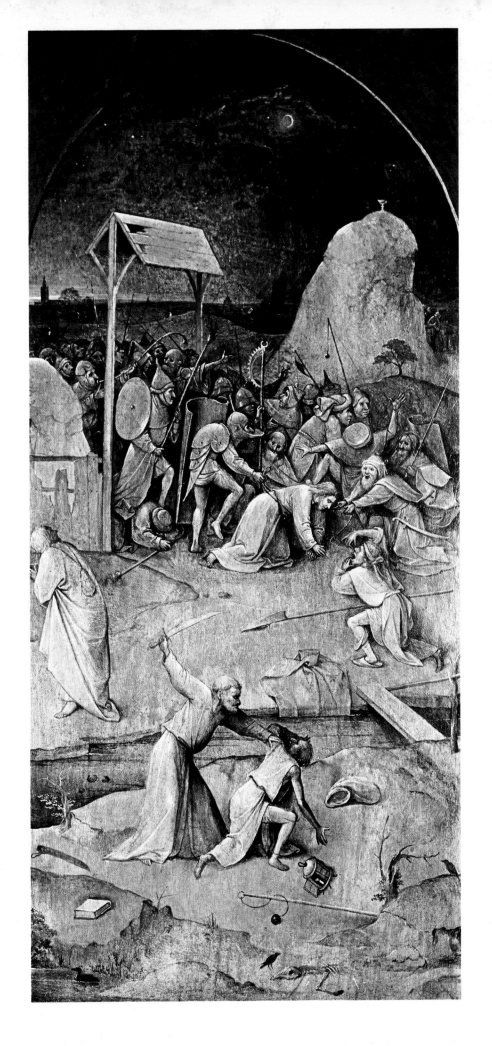

38. *The Temptation of St Anthony*

Right shutter: Christ on his way to Calvary
Oil on panel. $51\frac{3}{4} \times 20\frac{3}{4}$in (131·5 × 53cm)

Bosch's gifts as an observer of man's passions are evident
in this painting of Christ carrying the Cross to Calvary,
particularly in the gestures of the monks confessing the
doomed thieves, and the look of despair on the face of
the thief in the left foreground.

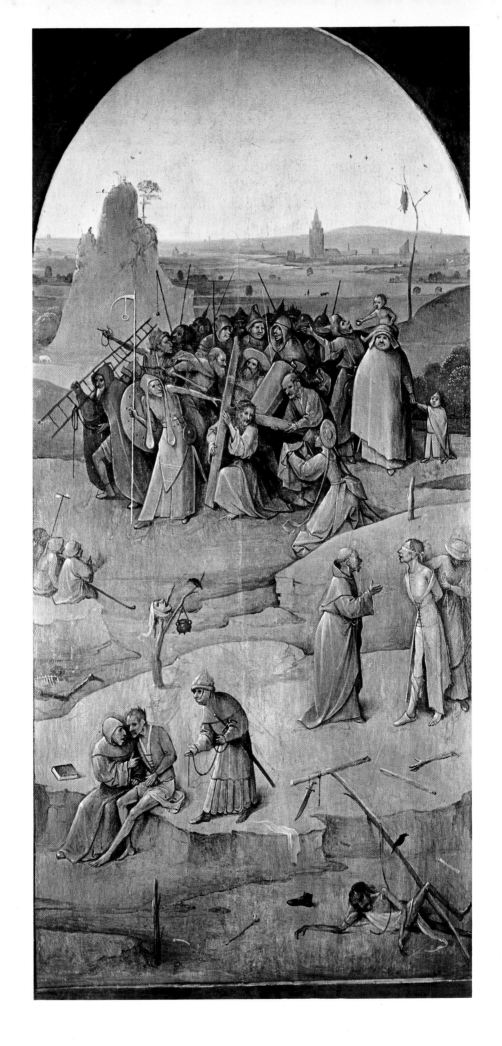

39. *Christ carrying the Cross*

Oil on panel. $30\frac{1}{4} \times 33in$ (76·5 × 83·5cm)

Generally thought to be a late work, this close-up view of Christ on the way to Calvary seeks to portray the distorting effect of cruelty on man. Christ is serene beneath the Cross, while his image, imprinted on St Veronica's veil, stares out at the spectator. Christ alone is unmoved by his fate, unlike the thief nearby who is pale with terror. Bosch here adopts the particular strain of mannerism which was then fashionable in Antwerp.

Ghent, Musée des Beaux-Arts

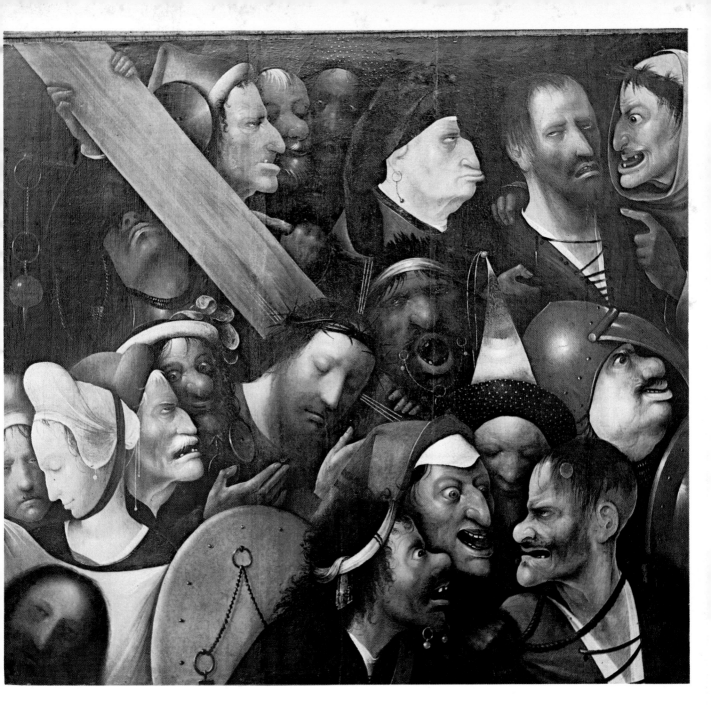

40. *The Temptation of St Anthony*

Oil on panel. $27\frac{1}{2} \times 20in$ (70 × 51cm)

This is generally considered to be a very late work, probably executed after 1510, in which Bosch returns to the subject of the great triptych at Lisbon. Now, however, he seeks to depict the saint's spiritual state and places less emphasis on the evil forms assumed by the devil to tempt him.

Madrid, Prado

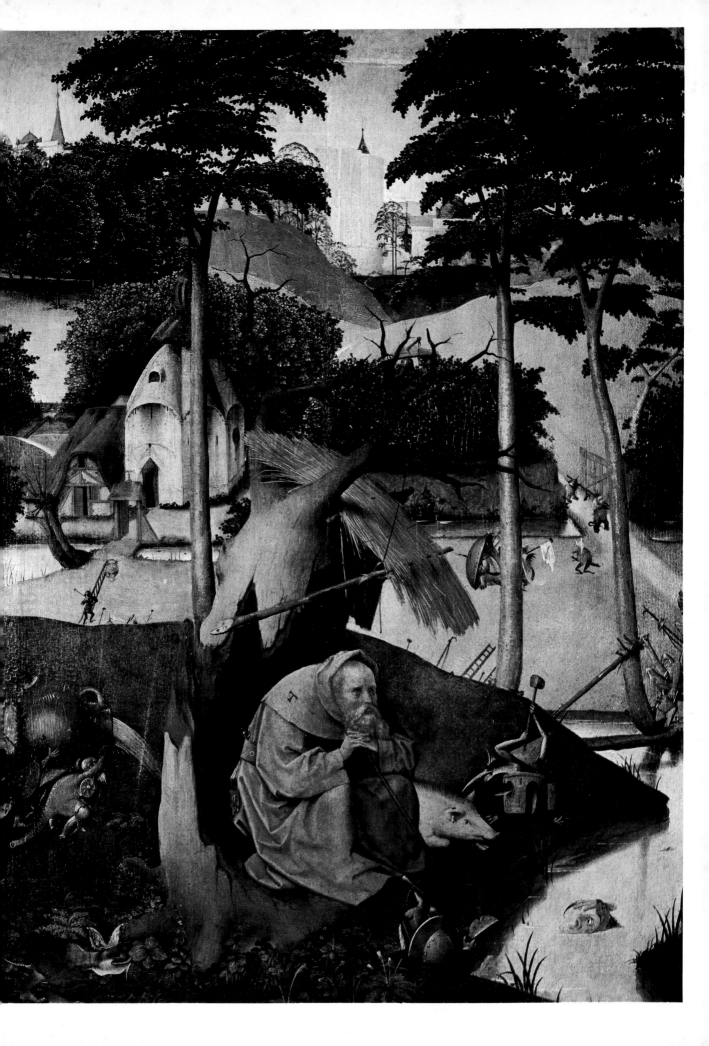

Acknowledgements, and list of illustrations and sources

THE AUTHOR AND BLACKER CALMANN COOPER LTD would like to thank the museums and owners who allowed works in their collections to be reproduced in this book. Unless otherwise stated they provided the transparencies used. The author and Blacker Calmann Cooper Ltd would also like to thank the photographers and photographic agencies who provided transparencies.